More Praise for *Performance Architecture*

"Out of the fog of conflicting and confusing definitions and applications of HPT comes this book. The authors are uniquely—uniquely—qualified to define the landscape of our field and then provide useful concepts and tools. It should be the first reference that a professional turns to in order to measurably improve performance and the payoffs for all stakeholders."

—Roger Kaufman, CPT, Ph.D., professor emeritus, Florida State University, and Distinguished Research Professor, Sonora Institute of Technology.

"The authors do a brilliant job of presenting a systematic structure, the HPT approach, in a way that allows newcomers easy access to the field. More than that: experienced practitioners might find ways to reorganize their habitual approaches and broaden their perspectives. Especially helpful are the Authors' Picks at the end of each chapter. Already this is an invaluable source for every practitioner. A must for any HPT library."

—Klaus D. Witthuhn, CPT, managing partner, Performance Design International GmbH

"Addison, Haig, and Kearny have developed a comprehensive, powerful approach to improve company performance and ensure change efforts are a success. The book is filled with tools, techniques, and systematic methods to analyze complex issues and develop effective, practical solutions. The authors' vast experience in successfully applying performance technology is illustrated throughout with case studies accompanied by related research on each area. Every practitioner will want this valuable resource in his or her toolkit."

— Bryan Lawton, Ph.D., chief governance and corporate development officer, The Doctors Company

"*Performance Architecture* begins with an important bird's eye view of how performance improvement works and then gets right into the specifics. It provides a valuable framework for managers plus the key principles and techniques for practitioners. Few authors are as qualified or capable as this trio to show the lay of the performance improvement land."

—Timm J. Esque, partner, Ensemble Management Consulting

"*Performance Architecture* provides the necessary structure for managers to systematically analyze performance shortfalls and develop broader solutions. Models, tools, examples, and application exercises are given to guide managers in improving workplace performance at all levels of their organizations. The book is a powerful resource for all managers seeking to learn and use human performance technology (HPT)."

—Roger Chevalier, CPT, Ph.D., independent performance improvement consultant and author of *A Manager's Guide to Improving Workplace Performance*

"If you are interested in an easy, concise and straightforward approach to diagnosing poor performance in your organization, then this book is for you. Frankly, managers become better managers when the suggestions and tools are utilized to address gaps in organization, process, and/or people results. This book should be a permanent 'tool' in a manager's tool box."

—Mark Munley, director, Strategic Business Partners,
AAA Northern California, Nevada, Utah

ABOUT ISPI

The International Society for Performance Improvement (ISPI) is dedicated to improving individual, organizational, and societal performance. Founded in 1962, ISPI is the leading international association dedicated to improving productivity and performance in the workplace. ISPI represents more than 10,000 international and chapter members throughout the United States, Canada, and forty other countries. The society reaches out to more than 20,000 performance improvement professionals through publications and educational programs.

ISPI's mission is to develop and recognize the proficiency of our members and advocate the use of Human Performance Technology. This systematic approach to improving productivity and competence uses a set of methods and procedures and a strategy for solving problems for realizing opportunities related to the performance of people. It is a systematic combination of performance analysis, cause analysis, intervention design and development, implementation, and evaluation that can be applied to individuals, small groups, and large organizations.

Website: www.ispi.org
Mail: International Society for Performance Improvement
1400 Spring Street, Suite 260
Silver Spring, Maryland 20910 USA
Phone: 1.301.587.8570
Fax: 1.301.587.8573
E-mail: info@ispi.org

**International Society for
Performance Improvement**
WHERE KNOWLEDGE
BECOMES KNOW-HOW

About Pfeiffer

Pfeiffer serves the professional development and hands-on resource needs of training and human resource practitioners and gives them products to do their jobs better. We deliver proven ideas and solutions from experts in HR development and HR management, and we offer effective and customizable tools to improve workplace performance. From novice to seasoned professional, Pfeiffer is the source you can trust to make yourself and your organization more successful.

Essential Knowledge Pfeiffer produces insightful, practical, and comprehensive materials on topics that matter the most to training and HR professionals. Our Essential Knowledge resources translate the expertise of seasoned professionals into practical, how-to guidance on critical workplace issues and problems. These resources are supported by case studies, worksheets, and job aids and are frequently supplemented with CD-ROMs, websites, and other means of making the content easier to read, understand, and use.

Essential Tools Pfeiffer's Essential Tools resources save time and expense by offering proven, ready-to-use materials—including exercises, activities, games, instruments, and assessments—for use during a training or team-learning event. These resources are frequently offered in looseleaf or CD-ROM format to facilitate copying and customization of the material.

Pfeiffer also recognizes the remarkable power of new technologies in expanding the reach and effectiveness of training. While e-hype has often created whizbang solutions in search of a problem, we are dedicated to bringing convenience and enhancements to proven training solutions. All our e-tools comply with rigorous functionality standards. The most appropriate technology wrapped around essential content yields the perfect solution for today's on-the-go trainers and human resource professionals.

www.pfeiffer.com

Essential resources for training and HR professionals

PERFORMANCE ARCHITECTURE

The Art and Science of

Improving Organizations

PERFORMANCE ARCHITECTURE

The Art and Science of Improving Organizations

ROGER M. ADDISON
CAROL HAIG
LYNN KEARNY

**International Society for
Performance Improvement**
WHERE KNOWLEDGE
BECOMES KNOW-HOW

A Wiley Imprint
www.pfeiffer.com

Published by Pfeiffer
An Imprint of Wiley
989 Market Street, San Francisco, CA 94103-1741
www.pfeiffer.com

For additional copies/bulk purchases of this book in the U.S. please contact 800-274-4434.

Pfeiffer books and products are available through most bookstores. To contact Pfeiffer directly call our Customer Care Department within the U.S. at 800-274-4434, outside the U.S. at 317-572-3985, fax 317-572-4002, or visit www.pfeiffer.com.

Pfeiffer also publishes its books in a variety of electronic formats. Some content that appears in print may not be available in electronic books.

Library of Congress Cataloging-in-Publication Data
Addison, Roger M.
 Performance architecture : the art and science of improving organizations / Roger M. Addison, Carol Haig, Lynn Kearny.
 p. cm.
 Includes bibliographical references and index.
 ISBN 978-0-470-19568-0 (pbk.)
 1. Performance technology. 2. Work environment. 3. Organizational effectiveness. I. Haig, Carol, 1946-
II. Kearny, Lynn. III. Title.
 HF5549.5.P37A33 2009
 658.4—dc22

2008051524

Acquiring Editor: Matthew Davis
Marketing Manager: Brian Grimm
Director of Development: Kathleen Dolan Davies
Production Editor: Michael Kay

Editor: Rebecca Taff
Editorial Assistant: Lindsay Morton
Manufacturing Supervisor: Becky Morgan

Printed in the United States of America

Printing 10 9 8 7 6 5 4 3 2 1

To Michael John Cullen for his continued support and tolerance.

To Cresson Kearny for being my rock and my compass.

In memory of:
Elizabeth Tosti Addison, an adventurous spirit and a true believer
Clarence "Mike" Marer, gentle father who cared so much
Geary Rummler, our mentor, advisor, and friend

CONTENTS

LIST OF FIGURES, TABLES, AND EXHIBITS

FOREWORD

Finally! I have been waiting for this book for ten years.

Although I have known Roger Addison for thirty years, I only began to work with him about ten years ago as one of his faculty in the ISPI "Transition to Performance" Institute he designed and manages. Overseeing these institutes is an appropriate role for Roger, whom I consider a master of this transition. He guided such a transition and managed the resulting performance improvement department at a major financial institution for seventeen years. To my knowledge, the most successful, and longest-running internal HPT show in the world. Roger's co-authors, Carol Haig and Lynn Kearny, were contributors to that successful performance improvement organization.

It was in the context of co-teaching these workshops with Roger that I saw the positive impact on participants of his first-hand experience, stories, and examples. These workshops have plenty of models and worksheets, but it is Roger's stories that really sell the idea that performance improvement is powerful and doable for those about to make the leap. So, for three years I suggested that Roger write down these stories. Then for three more years, I pleaded with him to get Carol and Lynn together and write this book. Finally, about three years ago I convinced Roger and his co-authors to come to my office in Tucson for several days, whereupon I locked the door and wouldn't let them out until they had a detailed outline for this book. So, as I said, "Finally."

Of course, this book is more than just those stories of Roger's. There are the rich experiences of Carol and Lynn, as they worked over the years with and without Roger. The book provides a practical HPT application framework for the novice and experienced practitioner alike. It also is a dynamite reference, compiled by quite possibly the most informed professionals in the HPT field.

But back to the stories, my initial stimulus for this book. As some of you may know, my work in the field of performance improvement favors comprehensive analysis models and big-bang projects. But those high-profile applications of the HPT principles can overshadow the reality that the true contribution of HPT is frequently in the smaller, day-to-day interactions with executives, managers, and employees; by asking a question no one else thought to ask, or by making a key observation or suggestion. These "HPT moments" frequently make major bottom-line contributions, by stopping a potentially stupid initiative or implementing a better, less costly, more sustainable change. As this book and the stories point out, every day there is a chance to make a difference with HPT thinking.

Geary A. Rummler
Founding Partner
The Performance Design Lab
Tucson, Arizona
August 2008

PREFACE

We three have been helping organizations improve the performance of their employees for over eighty-five years, and we want to share what we know that gets results. We use the models and tools included here ourselves. The suggestions we make come from our own experiences, and the examples we give are from our own work and from that of colleagues and friends.

Performance Architecture, both the concept and the model that forms the basis for this book, originated some years ago when Roger Addison, who is a great traveler, first saw a travel Access Guide. He was intrigued because the guide was organized as people actually travel—describing what they could see in a particular neighborhood in a city, for example, rather than by lists of attractions, restaurants, hotels, and the like. Roger visited The *Understanding*Business (TUB), the designers of the Access Guides, where he met Mark Johnson, then TUB president. TUB specialized in making information accessible through good design, and Roger saw that the way information is displayed contributes to performance improvement. Mark is an architect by training, and he and Roger had many conversations about design and its role in improving performance. In one discussion, they made the connection between performance and architecture. Putting the two together helped to refocus Roger on designing performance, rather than simply looking for gaps, and opened his thinking to include other disciplines, such as architecture and workplace design, in his performance improvement efforts.

Writing this book has helped us to recognize how much we have learned and has enabled us to integrate it into one big picture. Whenever we write about a subject, researching and reviewing material leads us to new insights and connections and updates information we have come to take for granted. Our exploration of new books and websites alone has been invaluable. The process also reminded us to view organizational politics more as a positive instrument rather than as a necessary evil. Finally, we recognize that in human performance technology (HPT) there is a less robust set of tools for working at the Organization Level than at the other levels. We hope this book will encourage others in our field to add much needed resources for this level.

It is quite possible that we would never have written this book without the special encouragement and support of Geary Rummler. Geary has known us for years, and we have used his materials in our work. He, in turn, knows our work, and encouraged us to get our ideas together in a book. Ultimately, he invited us to visit him in Tucson, Arizona (in July!), where he led us through the initial outline for this book and opened his treasury of tools and resources to us. We are very grateful.

Human performance technology and performance improvement have deep roots. We know that we build upon the work of many great thinkers, both from the past: B.F. Skinner, Lloyd Homme, Thomas Gilbert, George Geis, Bill Deterline, and many others; and from today: Dale Brethower, Clare Carey, Roger Chevalier, Bill Daniels, Judith Hale, Joe Harless, Paul Harmon, Stephanie Jackson, Roger Kaufman, Danny Langdon, Miki Lane, Robert Mager, Margo Murray, Ken Silber, Harold Stolovitch, Donald Tosti, Klaus Wittkuhn, Kathleen Whiteside, and so many more.

FIGURE P.1. *Geary's Treasure Chest*

Our special thanks to colleagues, bosses, friends, and family who cheered us on as we researched and wrote: Dannie Anderson, Rick Battaglia, Michael Cullen, April Davis, Matthew Davis, Barbara Gough, Cress Kearny, Bryan Lawton, Walter Ratcliff, Josie Trujillo, the staff of ISPI, and the editorial team at Pfeiffer.

Roger Addison, Carol Haig, Lynn Kearny
October 2008

INTRODUCTION

Organizations are increasingly focused on improving their industry and marketplace performance. Within their structures, a growing number of functions beyond human resources are searching for tools and information to help manage and extend employee performance to meet organizational goals. Gap analysis, for example, is a common activity in information technology, marketing and sales, operations, finance, and other functions for which many positions now require consulting skills.

NEED FOR THIS BOOK

Increasingly, people with responsibilities in areas other than human resources and training/organization development need tools to enable them to consult effectively in their specialties. As a whole, organizations know that they benefit from having workers across the spectrum that can share skills, knowledge, and resources to power performance.

PURPOSE OF THIS BOOK

The Performance Technology Landscape model drives this book. It provides a structure for readers needing tools and information to help achieve organizational results and build or increase their skills and knowledge in performance improvement. We identify and demonstrate how performance at three levels—Worker, Process, and Organization—impacts results, allowing you to scale your performance improvement activities for any project or initiative from small to large and be successful.

The Performance Technology Landscape provides the components that all practitioners, from beginner to advanced, student to professional, can access to acquire or improve their performance improvement expertise. We support each component of the model with tools and examples that have demonstrated value, were developed by respected contributors, and that we have used successfully ourselves.

SCOPE AND APPROACH

Consider this your user's guide to human performance technology (HPT), with tools and information systematically presented to explain the field of HPT and give you easy access. We share the best of our combined eighty-five-plus years of experience, showing you what works and why, and sometimes cautioning you about potential problems and how best to avoid them. We include lots of our successes and those of our colleagues and friends so that you can see how a model or tool can produce results.

We define terms as we use them and avoid acronyms wherever possible. We encourage you to talk with your clients using language that relates to the businesses they are in, rather than using the language of the performance improvement profession.

We suggest application exercises in several chapters to help you get to know specific models and tools we have found invaluable in our own work. And we include numerous resources to help you expand your professional library, find out more about a topic of interest, join a professional association, attend a developmental conference, and otherwise increase your expertise. Be sure to explore the Author's Picks at the end of each chapter for our must-have resources.

In addition to the many models and tools we have mentioned here, we include a number of illustrations developed by co-author Lynn Kearny, who not only draws, but also writes and consults about improving performance in the workplace. Lynn's illustrations clarify complex concepts, demystify intricate models, and are guaranteed to charm and delight you at the same time.

HOW TO USE THIS BOOK

The core of this book is the first chapter, The Performance Technology Landscape. It is the foundation for the other chapters, explains human performance technology, and is the map that will take you to where practitioners in our field work and show you what they do. We recommend that you read Chapter 1 first. It will help you determine where you'd like to go next.

Chapters 2 through 8 can be read either consecutively or in any order that meets your needs. Each chapter is self-contained and can stand alone. Wherever possible we refer to other chapters for more information or a different perspective on a subject under discussion. Every chapter contains a Where to Go Next table to point you to other chapters that may be of interest.

Chapter 2: The Worker: Individual/Team Level introduces the first of the three organizational levels and discusses representative issues that performance improvement specialists encounter here. You'll find models, tools, examples, and advice for approaching projects at the Worker Level.

Chapter 3: The Work: Process/Practice Level explores performance improvement challenges derived from the work done in organizations and the ways in which process and practice issues make themselves known. You'll discover proven methods for decoding work issues, with supportive models and tools to help you.

Chapter 4: The Workplace: Organization Level helps you navigate performance improvement concerns that originate in the upper reaches of organizations and may have created opportunities for changes in one or more of the other organizational levels. You'll discover effective navigation techniques, uncover clues to operating successfully out of your comfort zone, and gain an increased appreciation for organizational politics.

Chapter 5: Implementation: Weaving Performance into the Organization turns fresh eyes on what happens after project roll-out and helps you avoid having your project vanish before it can produce the results you promised.

Chapter 6: What We Do discusses the Systematic Approach at the core of HPT and shows how the kinds of performance improvement applied at each of the three organizational levels come together to produce results.

Chapter 7: Focus Forward: Trends to Watch is an emphatic nod to current trends in the workplace and in the world that affect the organizations where we help our clients. We select several critical, wide-ranging, and interrelated trends to help raise your awareness of the many challenges facing your clients. We also discuss what you can do to scan for opportunities to improve your organization's

results. This is the key to being a true business partner: become a proactive force for growing the organization's success.

Chapter 8: Chart Your Course is your opportunity to determine what you'd like to learn more about in the world of HPT. It provides planning aids to help you think about skills and knowledge to acquire at each of the three levels: for your own development, for that of your department, and for your organization.

FURTHER THOUGHTS

Human performance technology is a field the three of us have found endlessly fascinating and rewarding. The detective work of analysis, the architectural work of building solutions, and the collegiality that we have discovered in our chosen discipline has kept us engaged and interested for decades. We hope you will find these models, tools, and resources a real enhancement for your own career, and that you derive as much satisfaction from it as we have.

CHAPTER

THE PERFORMANCE
TECHNOLOGY
LANDSCAPE

Some years ago, a company had a team of high-performing data entry clerks that was known for consistently rapid production with very low error rates. These were skilled, dependable employees who had worked together for a long time. When their company moved to a new and much larger building, the clerks were delighted with their workspace. They loved their spacious office, large wrap-around windows, and restful views of lush lawns and shady trees.

When they moved, they brought along all their existing office furniture, state-of-the-art computers, and other equipment. They settled into their wonderful new space and continued with their work. After a week or two, their manager reviewed the production reports and was surprised to see that the team's error rates had noticeably increased. He searched in vain for an obvious reason and could only conclude that the move had somehow disrupted the clerks' usual accuracy.

When this alarming trend continued through several reporting cycles, the manager decided the best course of action would be to retrain this group of skilled high performers because they had obviously forgotten how to do their jobs. So all the data entry clerks were retrained. And, as you may have guessed, their sub-standard performance continued with subsequent reports showing no reduction in error rates.

In desperation, the manager asked the performance consulting department for help and a consultant paid him a visit. After the manager brought her up-to-date on events, she asked to see all the reports from after the move and several sets from before to compare the clerks' performance.

After reviewing the reports, the consultant shared her findings with the manager. In the reports generated since the move to the new building, she noticed a definite pattern of increased errors in the late afternoons. The manager could not immediately provide an explanation for this, so the consultant asked if she could spend a few days on the floor to observe the clerks and learn more about their jobs.

When her observations were complete, the consultant met with the manager to again share her findings. Those large, bright windows really let in lots of light. In the late afternoons, as the sun began to set, it created glare on the clerks' computer screens. Even though they knew their software well, it was easy to make mistakes and not see them; hence, the increased error rates.

The manager was somewhat embarrassed to have missed this obvious reason for poor performance, but the consultant helped him see the value of another pair of eyes when trying to diagnose a problem from inside the situation. She pointed out the power of observation in analyzing performance problems and confided that she never fully believed anything her clients told her until she went to see for herself. The manager forgave himself his oversight and was pleased to discover that window coverings were a relatively quick and inexpensive solution to a critical performance obstacle (Addison & Haig, 2006, p. 35).

WHERE WE WORK

"Where do you work?" When asked that question by a new acquaintance at a party, we may say, "I work for the City," or at a company-wide meeting, "I work in Customer Service," or even, "I work downstairs in Shipping," in response to an inquiry in the elevator. But what would happen if we said, "I work in Performance Technology"? This would be a truthful answer for anyone in the field of performance improvement, but would probably elicit a puzzled look from the questioner.

Welcome to the territory of the performance improvement professional. We inhabit a place of great mystery to many, and yet with careful explanation, examples, illustrations, and stories, much of what we find on the Performance Technology Landscape is familiar to others in our organizations who may be technicians, supervisors, executives, or front-line workers. Here on the Landscape we de-code performance issues and structure solutions to improve the results workers achieve in their jobs.

As the designated architects of improved performance in our organizations, we rely on a body of experience, proven approaches, and documented successes to help our clients provide an environment in which workers can meet and exceed expected performance results. The Performance Technology Landscape is our guide to designing and building Performance Architecture. Performance Architecture comprises evidence-based designs, plans, models, and tools that guide the integration of the Worker, Work, and Workplace to improve performance in organizations.

Let's begin by exploring the features of the Landscape. To help explain what we find, we'll use our combined eighty-five years of performance improvement experience coupled with the valuable work of such notables as Dale Brethower, Judith Hale, Paul Harmon, Lloyd Homme, Tom Gilbert, Robert Mager, Margo Murray, Geary Rummler, Harold Stolovitch, Don Tosti, and others. These

practitioners are among those responsible for building the foundation of performance technology; they have contributed through their work, and documented it in publications (Addison & Haig, 2006, p. 36).

THE PERFORMANCE TECHNOLOGY LANDSCAPE

The Landscape (Figure 1.1) houses the vital components of the work of human performance technology (HPT). HPT is an integrated system approach to performance improvement that is illustrated by the multiple dimensions of the Landscape:

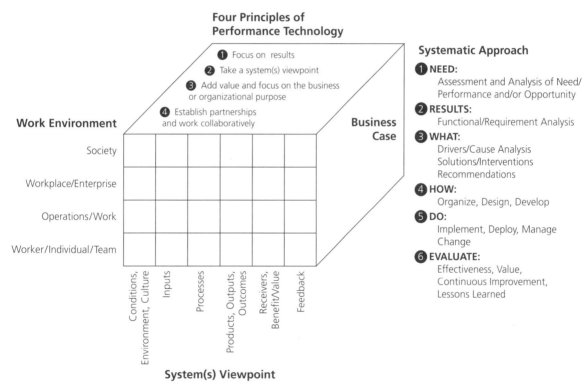

FIGURE 1.1. *The Human Performance Technology Landscape.*

Source: Addison, R. (2004). *Performance Improvement,* July 2004, *43*(6), 15. Reprinted with permission of John Wiley & Sons.

To help us further explain the Performance Technology Landscape are two key concepts: performance and human performance technology.

What Is Performance?

While many of us might think of performance as simply an activity on the Performance Technology Landscape, seasoned performance improvement professionals add a critical component; a result (Addison & Haig, 2006, p. 38). So, performance = activity + result, as in reading a blueprint, *activity*, and following it to build a house, *result*. We further stipulate that the result must be of *value*. In this example, building a house provides a family with shelter. The value is in the importance of the house to all stakeholders: the resident family, guests, neighbors, builder, architect, property tax collector, etc. Performance can be further defined as "those valued results produced by people working within a system" (ISPI, 2004, p. 9).

What Is Performance Technology?

We define a technology as a set of empirical and scientific principles and their application; applied knowledge, and science. Performance technology (PT) is a technology that includes all of the variables that affect human performance. We use PT in the workplace to identify the factors that enable workers to perform their jobs and produce desired results. PT provides tools and processes to identify opportunities for improved performance, valued solutions, and return on investment, as well as the building blocks to construct new performance environments and systems. In brief, HPT:

1. Focuses on valuable, measured results;

2. Considers the larger system context of people's performance;

3. Provides measurement tools that can be used repeatedly and will consistently show the same outcome; and

4. Describes programs and solutions clearly enough to be duplicated by others.
 (ISPI, 2004, p. 4)

We frequently find our clients confused by the term technology because they think of it as machinery, or equipment, or automated systems. It is helpful to explain technology as the dictionary does, "The application of knowledge especially in a particular area" (Merriam-Webster, 2003).

Interpreting the Performance Improvement Terrain

The PT Landscape functions as scaffolding for performance technologists, providing a base from which to view the ways we can build improved human performance and increase value to the client organization. A closer look at the PT Landscape calls out four critical components of effective results: Principles of Performance Technology, Work Environment, System Viewpoint, and Systematic Approach.

PRINCIPLES OF PERFORMANCE TECHNOLOGY

Performance improvement professionals adhere to four principles in our work, often expressed as RSVP+:

R—*Focus on results:* Use our knowledge of the business to help clients link their performance improvement initiatives to business needs and goals, and initiate such projects by specifying what the end result is to be.

S—*Take a system viewpoint:* Consider all aspects of the organization's performance system when we analyze a situation, including competing pressures, resource constraints, and near and long-term anticipated changes.

V—*Add value:* Produce results that make a difference, both in how we do the work and in what we produce.

P—*Establish partnerships:* Work with clients and other performance improvement professionals to share skills, knowledge, creativity, and successes to produce the intended results.

+—*Remain solution-neutral:* The + in RSVP+ reminds us that as ethical performance consultants we stay focused on the client's needs/requirements and remain solution-neutral, recommending what is best for the client's situation regardless of our solution preferences or personal expertise.

Using RSVP+

These principles can serve as valuable guides for performance consultants. For example, results are most often expressed in terms of profits or growth, such as increasing profit or growing market share by a specific percentage. It is important to link our results to critical business, process, and individual measures.

What is the system in the client organization you work with? Is it a series of functional silos? For initiatives to become part of the organization's fabric, processes must be aligned across the system. Take a look at industry leaders, such as Hewlett Packard, where project teams from functions and locations around the world come together, often virtually (Friedman, 2007, p. 207).

What is the quality of the system? We know that a bad system is pervasive and will override the best performer's efforts. The same bad system will overwhelm a good customer's legitimate complaints, enabling resolution of the complaint but without changing the system (Rummler, 2004, p. xiii). Know the environment into which you plan to introduce change.

Partnerships are critical. When you look around your organization you will find lots of people trying to improve performance in their own areas. Consider the power of a broad group of stakeholders partnering for the same goals. Today, if an organization isn't thinking horizontally, it is not innovating.

Organizations get what they measure, and they measure what is of value to them. Don Tosti recommends that we align our practices with the organization's values (in conversation with Don Tosti).

And finally, RSVP makes a wonderful frame on which to construct an elevator speech to describe your work. Try creating several short statements that touch on each of the principles and see what you can build (Haig & Addison, 2007). See Chapter 8, Chart Your Course, for more on the elevator speech.

By thinking systemically, we are able to identify and work with all the linkages in organizations as we strive to improve performance (Addison & Haig, 2006, p. 39).

WORK ENVIRONMENT

In organizations work is performed at three, and sometimes four, levels:

1. *Individual/teams:* the worker level

2. *Operations/process:* the work level

3. *Organization/enterprise:* the workplace level

4. *Society:* the communities served, the world

Performance consultants determine where issues originate and how they permeate the various levels to make sure that our investigations are complete. A client may, for example, identify an issue as originating with an individual worker or a work group. We may dig deeper to discover that, while the issue affects individual workers, its source is a work procedure at the process level. Then we strategize differently based on where the issue "lives." One strategy for a performance issue that originates at the individual or worker level is to raise its level to make it more visible and thus gain additional support for resolution.

At the work or process level, we identify all the functions impacted by the process under investigation, working horizontally to ensure that relevant stakeholders are partnering to make the needed changes.

For a workplace or organizational level issue, we show how it impacts the entire enterprise, including suppliers, customers, and the competition.

For many years Roger Kaufman has brought our attention to working at the societal level (Kaufman, 2006). In his most recent book, Thomas L. Freidman presents his argument for a green revolution (Friedman, 2009). Many organizations today acknowledge society as a fourth level where they, as good corporate citizens, can make valuable contributions to the environment, the economy, and to the communities they serve. This service may involve encouraging employees to contribute their efforts to local charities, such as the Volunteer Day program or the seventy-eight Community Involvement Teams at Levi Strauss worldwide (www.levistrauss.com/responsibility). Another example is through active support of humanitarian issues as with Hewlett Packard's Design-for-Environment program (www.hp.com/hpinfo/globalcitizenship/environment/productdesign/design.html) that provides environmentally sustainable products through recycling services, or the Siemens Arts Program (http://w1.siemens.com/responsibility/en/citizenship/artsprogram/into.htm) that supports and advances local arts and culture in company locations around the world.

Performance improvement professionals also work at the societal level, using HPT tools and techniques to address broad areas of need in the developing world (Haig & Addison, 2002; Kaufman, 2006).

Whenever possible, performance improvement practitioners expand their work to higher organizational levels to increase the impact of improved performance and add value for the organization. Many practitioners are accustomed to working with individuals or teams to improve performance. However, organizations realize broader, longer-lasting gains in performance improvement when we work across the organization rather than escalating because the customer is ultimately affected (Figure 1.2).

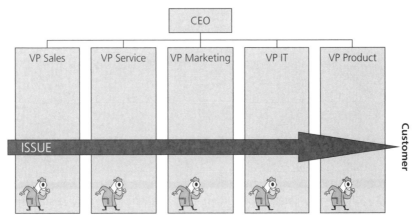

FIGURE 1.2. *Worker, Work, Workplace Issues.*

HOW WE THINK—SYSTEM, SYSTEMATIC, SYSTEMIC

Just as architects view the total project as a system as they plan and design, we in HPT see the organization as a system, thus differentiating ourselves from other disciplines with our system viewpoint.

System Viewpoint

HPT professionals consider that every organization is, by definition, a system, and that all components of that system are related. Therefore, when performance improvement is needed in one component we consider all of them in our investigation. Any place we touch in the organization will affect other areas because the organization is a system. This is often referred to as thinking systemically. The System Model in Figure 1.3 is representative of this basic HPT principle. Many performance improvement professionals have their own version of this model.

We make the greatest impact on performance when we address the whole system. As the System Model illustrates, performance begins with Inputs into a system, which are processed until the Results reach the Receiver; hence, performance occurs from left to right. Performance improvement specialists, however, work from right to left, beginning by clearly identifying the desired Results of an initiative and then working backward through the model to Inputs (Addison & Haig, 2006, p. 40).

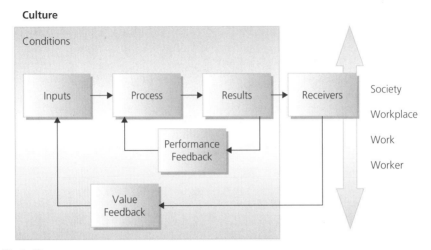

FIGURE 1.3. *System Model.*

Thinking Systemically

By thinking systemically we are able to view the enterprise as a complete system made up of the following components (adapted with permission from ISPI, 2004):

■ *Receivers:* The people who receive or are directly affected by the result—the stakeholders

■ *Results:* The products, services, or any valued result produced by a process

■ *Process:* The sequence of actions in the value chain that produces the desired results

The Organizational or Workplace Level focuses on those processes concerned with the governance of the organization.

The Operational or Work Level includes all the processes in the value chain as well as those that maintain them. The variables here take into account the specific activities and tasks and their sequence and flow. At this level we often look for broken connections and misalignments such as bottlenecks and disconnects.

The Performer or Worker Level is focused on the actions of the individual. It therefore seems best to put the performer in the Process box. The variables to be considered are those internal to the performer that are relevant to the execution of the task. These include:

■ Skill or knowledge

■ Motivation

■ Other variables such as confidence, preferences, practices

It may be useful to think of two types of processes. Some, such as sales or service, touch the customer. Others, like employee payroll or recruitment, enable the organization to function. Ultimately, organizations require both types of processes to be effective.

Inputs: Everything that initiates or is used during a process including customer requests, stakeholder demands, information, the strategic plan, tools and equipment, work schedules, assignments, and support.

Conditions: The surroundings or environment within which performance occurs such as economic and market trends, industry norms, the physical, business, and social environment. This includes the physical workspace, as in the story of the data entry clerks that introduced this chapter.

Performance Feedback: Information about the quantity or quality of outputs that is fed back to a performer, operational unit, or organization from within the system. It can be used to make adjustments that will improve the results.

Value Feedback: The same type of information as provided by Performance Feedback, but originating from outside the system. Sources may include end users, stockholders, the surrounding community, the media, and so forth (Addison & Haig, 2006, p. 41).

Remember that performance feedback comes from within the system and value feedback from outside. One of us explains the difference this way: When the chef tastes the soup it is performance feedback; when the customer tastes the soup it is value feedback.

System thinking is scalable and can be applied at any of the three organizational levels: worker, work, or workplace.

Systematic Approach

Performance improvement professionals use a systematic approach to organize projects. They follow sequential steps and create a replicable process to identify needs and recommend solutions, shown in Table 1.1.

TABLE 1.1. **Systematic Approach.**

Step	Action
1. Need	Identify and review the problem or opportunity with the client
2. Results	Assess current performance against expected results and identify requirements for success
3. What	Identify sources of current performance and recommend solutions
4. How	Design and develop selected solution
5. Do	Implement approved solutions and put change management processes in place
6. Evaluate	Monitor performance against the expected results defined initially

Finally, performance improvement specialists take care to nurture and enhance the business partnerships we have established with our clients (Addison & Haig, 2006, p. 42).

HPT AS THE INTEGRATOR

Today, it is common to encounter numbers of people within organizations whose goal is to improve performance. They use a variety of approaches that have become familiar:

- Training is focused on providing individual employees with skills, knowledge, and abilities

- Six Sigma addresses processes and their creation and improvement

- Organization development addresses organizational workplace issues

It is beneficial for an organization to have a widespread interest in performance improvement. However, the professionals working in the disciplines just described are often in different parts of the organization and may be looking vertically, within their own functional areas.

We suggest that HPT methods, tools, and techniques can be used to integrate performance improvement initiatives horizontally across the organization. The power of Performance Technology is not in emphasizing the means but rather the ends. The integration of the worker, work, and workplace is a key to improved organizational performance (Addison, 2007).

CONCLUSION: LESSONS OF THE PERFORMANCE TECHNOLOGY LANDSCAPE

The Landscape has become a touchstone for us as performance improvement professionals. When we want to check the validity of a concept, a model, a tool, or an approach that is new to us, we come back to the Landscape. We look to the Landscape to show us where the new item fits in the performance world, how it supports the Principles of Performance Technology, at what levels of the work environment it could be effective, and to what extent it would mesh with the existing culture. Everything we do, or that can be done, to improve performance is contained in the Landscape.

The Landscape shows us that we can be effective and efficient in our organizations, and we can affect performance if we accurately diagnose what is getting in the way of results and recommend effective solutions. It is not necessary to study for years to do this work. With the right tools and resources, and the skills to decode them, performance improvement specialists can excel at what makes us unique: diagnosis.

WHERE TO GO NEXT

To learn about . . .	Go to . . .
Worker/Individual/Team Level	**Chapter 2**
Problem Solving	
Analysis	
Tie to the Business	
Models and Tools	
Work/Process Level	**Chapter 3**
Process	
Critical Process Issues	
Practice	
Maps—Making It Visible	
Workplace/Organization Level	**Chapter 4**
Mapping the Organization	
Critical Business Issues	
Problem Solving: Alignment	
Proposing Solutions	
Implementation	
Related Management Practices	
Models and Tools	
Implementation: Integrating Performance into the Organization	**Chapter 5**
What Is Implementation	
Episodic Versus Systemic	
Failure Versus Success	
Making It Stick	
Models and Tools	
What We Do	**Chapter 6**
Systematic Approach	
Project Management	
Models and Tools	
Focus Forward: Trends to Watch	**Chapter 7**
Trends That Impact Clients	
Natural Resources	
Technology	
Economics	
Performance Improvement	
Chart Your Course	**Chapter 8**
Worker/Self	
Work/Process	
Workplace/Organization	

AUTHORS' PICKS

Here are some of our recommended additions to your library and subscriptions you might enjoy.

Library Additions

Gilbert, T.F. (1996). *Human competence: Engineering worthy performance.* Washington, DC, and Amherst, MA: ISPI and HRD Press.

Hale, J. (1998). *The performance consultant's fieldbook: Tools and techniques for improving organizations and people.* San Francisco, CA: Jossey-Bass.

Pershing, J.A. (Ed.). (2006). *The handbook of human performance technology* (3rd ed.). San Francisco, CA: Pfeiffer.

Rummler, G.A. (2004). *Serious performance consulting: According to Rummler.* Silver Spring, MD: International Society for Performance Improvement.

Stolovitch, H.D., & Keeps, E.J. (Eds.) (1999). *The handbook of human performance technology* (2nd ed.). San Francisco, CA: Jossey-Bass/Pfeiffer.

Zemke, R., & Kramlinger, T. (1982). *Figuring things out: A trainer's guide to needs and task analysis.* Reading, MA: Addison-Wesley.

Subscriptions

Performance Improvement Journal—as a member benefit or as a subscription for non-members. Available: www.ISPI.org

Harvard Business Review—available: www.insightfromhbr.org/1107voucher/voucher.cfm

CHAPTER
2
THE WORKER: INDIVIDUAL/TEAM LEVEL

In a meeting room, twelve people sat around a large table discussing the need for a training program for the three hundred customer care managers in the field offices of their statewide insurance company. These managers, historically overlooked for formal developmental opportunities, had learned and successfully applied techniques for improving productivity, reducing customer wait times, and creating processing efficiencies that reduced costs and improved the customer experience. But now, a few years later, these same customer care managers were failing to delegate lower-level tasks, working extensive hours, and going out on stress leave in alarming numbers.

Why was this happening and what should be done about it?

The finance manager who hosted the meeting wanted to teach the customer care managers "the next level" of productivity improvement techniques and asked how big the course binder would be. The human resources manager observed that many field offices had vacancies and some were so short-staffed that the customer care manager had no one to delegate to. An operations project manager suggested that job aids be given to various field office employees so they could do tasks without requiring a customer care manager to show them how. A district manager wondered whether the customer care managers were clear about their priorities.

At one end of the table, two performance consultants listened and worked on a large-format document, entering information from the discussion and noting questions to ask the group. They saw that the customer care managers faced several challenges, all of which required further investigation and clarification. They were fairly certain, even at this early stage, that while the challenges would have to be addressed, training was not likely to be a viable solution for most of them because the customer care managers had been performing well until very recently.

Citing the variety of issues raised during the meeting, the consultants proposed that they develop a plan for further analysis, discuss it with the finance manager, and then proceed to investigate each of the issues to learn more about the causes of the current situation.

After the meeting, the consultants wisely assumed that their analysis would be broad and would likely uncover new issues along with expanded information on what they had learned so far. Their initial list of issues and problems included:

- Lack of delegation skills

- Staffing needs

- Staff training

- Setting priorities

Their analysis plan included:

- A review of representative transaction and volume reports, data on customer care managers currently on stress leave, recently resigned or terminated, or currently on probation

- A review of the hiring process for field office staff, and current training practices for new hires

- Individual interviews with the stakeholders from the meeting, or their representatives, and some customer care managers

- Observations in the field offices to watch the customer care managers at work under the current strained conditions

- Participation in customer service staff meetings and perhaps district meetings to hear and observe related information

The consultants planned to use the analysis to verify their starting assumptions about the issues facing the customer care managers and to uncover additional concerns. The consultants were mindful of their entry point at the Worker/Individual/Team level of their company, and considered that some new issues might surface that would point to the Work/Process Level or even the Workplace/Organization level. They thought they could leverage their analysis findings, as they gathered information, to help their client, the finance manager, broaden her view of the situation and consider a set of possible solutions beyond the training she envisioned.

But first, the consultants focused on specifying the performance gap as they scheduled their analysis activities and launched the project.

SUMMARY OF THE TECHNOLOGY

Among the professionals currently working in performance improvement, many began by providing services at the Worker or Individual level in their organizations. At this level, performance consultants might work with all the employees in a particular job category, such as all the sales clerks in the women's shoe department. We might also be helping a work group or team, such as the disaster recovery department, that has a range of different specialists working together. Or we could be consulting to a manager or supervisor about the performance of one or two employees in her work group.

Often, the concern that brings the performance consultant in, such as, "These people need to communicate better," is only one aspect of the real issue or may be a symptom of an entirely different matter. Our job then becomes one of investigating the situation to find out what is really happening.

APPROACH

The performance improvement professional is like a medical doctor, collecting information about the workers and their environment to better understand the issues affecting their performance. A doctor collects a patient's medical history, learns about the environments where the patient lives and works, and identifies possible symptoms. The performance consultant follows a similar path to learn about the worker's performance issues.

Once understanding is established, the performance improvement specialist is able to identify the specific issues and diagnose their causes. Three critical techniques for the doctor/consultant are problem solving, questioning, and a good bedside manner.

Problem Solving

Problem solving at the Worker level can be divided into two phases: diagnostic and prescriptive. During the diagnostic phase, we collect information by reviewing existing data, conducting interviews, distributing questionnaires, and observing the work environment. The results of diagnosis are:

■ Identification of the critical worker issues

■ A clearly defined gap between the current situation and the desired situation, and

■ A statement of the business opportunity that performance improvement can leverage

We recommend a broad approach to diagnosis: use more than one data source and at least two different data collection methods. Be sure that management is just one of the sources you consult, and always include observation as one of your methods. Only after you have a complete understanding of the performance problem or opportunity can you move to the prescriptive phase to recommend a solution. Here is a closer look at the data collection process we recommend.

Existing Data Review. Most organizations collect quantities of data and compile numerous reports, and what they collect is what is important to them. Chances are the information you are looking for is in an existing document. Good places to look for information are in:

■ Annual Reports

■ Government Reports

■ Customer Service Reports

■ Production and Quality Reports

■ Call Center Reports

If you are uncomfortable interpreting statistical data or if financial information makes you numb, take the finance manager to lunch. Everyone likes to share expertise, and having a department head

help you understand how the organization collects and uses data will make both of you happy. Bonus: you will gain a valuable organizational resource. Your new friend will help you locate the data you need or set you up with an analyst who can navigate the reports with you and simplify your search.

Interviews. At the core of an interview, whether one-on-one or a group conversation, is the planning of questions and the capturing of the answers and resulting discussions for further analysis. We think it helps to be unabashedly curious, nosey even, to gain the full benefits of judicious questioning. Here we share the best techniques we have learned from our colleagues and our own experiences.

According to Klaus Wittkuhn (in conversation with, 2008) the diagnostic questions we ask in information-gathering interviews serve to:

- Build rapport

- Get information

- Give information

Indeed, the best interviews are wide-ranging conversations in which the person(s) being interviewed gain as much value as the interviewer.

Don Tosti uses a method, which he calls Discovery (Tosti, 1980) with everyone he interviews. He finds it particularly valuable for gathering information from clients.

Build Rapport. Establish an open and sharing environment. Tell your client why you are there, the purpose of the meeting, and about how much time it will take. This discussion begins the foundation of your relationship with your client and establishes the partnership.

Explore. To get the information you need to understand the issues and opportunities, there are three helpful types of questions to use:

- Closed questions that can be answered by a yes or no:

 - Do you have a mission statement?

- Open questions to expand the discussion—often beginning with who, what, where, when, how:

 - What is the problem or opportunity?

 - Who is the performer who is having the problem?

 - Where does the opportunity exist?

 - Where does the problem occur?

 - When does the problem occur?

 - Is this issue worth pursuing?

- High-gain questions to encourage thought are also useful in getting to the core issues:

 - Tell me what is happening.

 - Tell me what is not happening.

- What do you think would solve the problem or realize the opportunity?

- What would you like to see happen?

- Who are your best performers?

- If you could only identify one key stakeholder in the process, who would it be?

Tie to the business. Ask thought-provoking questions such as:

- What does this change mean to the organization?

- What are the consequences of this initiative?

- What does it mean for the worker, work, workplace and the greater community?

- How would others in the organization describe the current situation?

Give Information. It is also important to provide information during this phase to help focus the interviewees on parts of the issue they may not have considered. The purpose is to help the interviewees to start thinking differently about the situation and to challenge them to generate new perceptions and understanding. You might say to an interviewee: "Your phone sales reps have to fill out so many screens that there is little time to probe for callers' buying criteria. What is being done to offset that?"

Closure. This is the last part of the discussion. The purpose is to make sure that next steps and agreements are clear and to increase the likelihood of client follow-through. One of the most important results of your discussion is to hear the client say, "I am glad we had this time together" and express confidence that some action will take place.

Observation

Two types of observations help performance improvement practitioners exercise their understanding of the client's needs. The first is to watch people while they work and the second is to look at documents or work samples. Ask to observe an exemplary worker and an average worker. You will want to see the differences and similarities in what they do and what they do not do. As you observe these people, you will want to see what is happening and not happening.

At the start of your observation, be sure to tell the workers, supervisors, and managers why you are there. Be clear up-front that you are there to learn about the jobs they do and the environment in which they do them.

Hands-On Experience. Some of the most successful observations we know of had the performance consultant actually doing the job he went to watch. One organization asked their consultant to work as a customer service representative for a week. Another consultant working with a local police department rode along with a patrol officer on a Saturday night to experience the reality of community law enforcement.

In the course of our own observation experiences, we have answered customer questions in a call center, acted as a customer greeter in a bank, and used an information technology company's intranet to find answers to employee benefit questions.

The purposes of these hands-on observation techniques are to:

- Find out what activities the workers perform

- Follow the procedures they are following

- Experience their work conditions, climate, and environment

- Find out the skills, knowledge, and abilities required for successful performance

- See how the performers interact with others and with customers

- Discover how workers complete required documentation

Bedside Manner. If you are approachable and easy to talk to, your clients and everyone you interview will feel comfortable sharing information. Cultivate a good "bedside manner" to speed rapport building and the gathering of information. Others will trust you if they perceive your competence, confidence, and your understanding of their organization's culture.

Competence. As a performance consultant, your competence is your "street cred," established by what you know about organizational performance, results, systems, measurement, design, and implementation, and by the visible work you have done successfully.

Confidence. Your confidence comes from the ease with which you interact with others. Some helpful tactics include:

- Use the other person's name

- Begin the conversation with a topic that is easy to discuss, like the weather, family, sports, or current events

- Speak in an even, calm, relaxed tone

- Match your speaking pace with the other person's

- Show appreciation for and acknowledge the accomplishments of the other person

- Make eye contact and smile when appropriate

- Demonstrate your interest in the person's business by asking questions

- Describe how you can help solve the problem or maximize the opportunity

HELPFUL MODELS AND TOOLS

Despite your skills, experience, and personal charm, much of your professional credibility and success in performance improvement comes from your knowledge of which models and tools can help expand your understanding of your client's problems and opportunities. We share three of our favorites with you here: the Total Performance System, the Performance Map, and the Iceberg.

Total Performance System

The second principle of Performance Technology, as discussed in Chapter 1, The Performance Technology Landscape, is "Take a system view" or think systemically. Every organization is a system. Understanding the elements of this total performance system and how they interact is one of the keys to superior performance consulting, because any change in one part of the system will ultimately affect all its parts.

There are two views of an organization that can be helpful. One perspective is from the traditional organization chart, a functional view, and the other is from a system viewpoint. The system viewpoint is an efficient way to identify critical indicators, interdependencies, changes, and unique characteristics.

Performance, as defined in Chapter 1, The Performance Technology Landscape, is activities plus results. There is no performance unless both conditions are met. We use the Total Performance System to show us the components of performance in a client organization and to specify the results produced. Table 2.1 is a way to organize the elements. Review the definition for each element in the table, consult the appropriate examples for guidance, and list the specifics for your client organization.

TABLE 2.1. **Total Performance System.**

Element	Definition	Example
Receivers	Anyone who receives or is affected by the results of the performance system, stakeholders	Customers, shareholders, subscribers, patients, board of directors, investors
Results	Accomplishments, consequences, outcomes	Market share increased, profits increased, overhead decreased
Outputs	What process delivers Including services, products, plans, ideas, added value that is produced by the process	Product shipped, patient cured, innovative product created, payments made, product sold, customer satisfied, goals met
Processes	The way work is done, a system that processes inputs, generating at least one output valued by the receiver	Work flow (order fulfillment), work procedures (ring up a sale), individual work habits (how a performer packs a carton)
Inputs	Elements that start the work processes or are used by it, materials that initiate or are resources for a work process	Information, technology, people, money, equipment and supplies, sales and production goals, sales orders, delivery vans, customer service calls, complaints

(Continued)

TABLE 2.1. *(Continued)*

Element	Definition	Example
Conditions/ Business Environment	The environment where work takes place, including physical conditions, business conditions in the organization, in the marketplace	The economy, government regulations, the market, fashion or trends, the environment
Performance Feedback	Information about the performance of individuals, work groups, or processes that is used to guide performance; it regulates the system; information about the quality (speed, accuracy, style, etc.) of the output that is used to keep the performance system operating most effectively	Performance evaluations, output against standards, praise or complaints, benchmarks against best practices
Value Feedback	Information from customers and other external sources used to guide performance; value or benefit: what the results are worth to customers, owners or anyone else who receives or is affected by the results of the performance system	Market share increases or decreases, sales rise or fall, customer complaints increase or decrease, voters change party or candidate, subscribers renew or cancel, fans come or go
Culture— Organization and Region	The management style, practices, and norms of the organization; a preferred way people behave, the way we do things around here, the culture and the behavior of people in this part of the world	People speak their minds, people keep their thoughts to themselves, people look for others' mistakes and point them out, people talk, laugh, and joke a lot, people prepare elaborate documentation before taking any new action, people don't speak to others in different units or levels, unless told to

Adapted from the work of Dale Brethower, Geary Rummler, and Donald Tosti.

We like the Total Performance System because it helps us organize what we learn about an organization as we clarify our understanding of the activities and results that produce performance in that environment. We find this model to be scalable; it is as effective for an entire global organization as it is for one division or department.

The Performance Map

We find that we can increase the likelihood of a successful performance improvement engagement when we involve the requestor at the start. The Performance Map is a particularly useful tool to help a client move from requesting a training solution to understanding why a performance solution may be more effective.

The Performance Map in Figure 2.1 helps diagnose performance-related issues. Whether to solve a problem or create an opportunity, the Performance Map's simple grid format is easy to explain to managers who often respond by picking up a pen and actively engaging with the Map (Addison & Haig, 2006, p. 44).

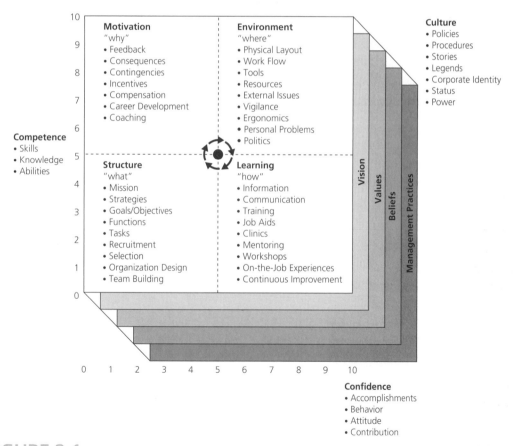

FIGURE 2.1. *Performance Map.*

Source: Addison, R.M., & Haig, C. (2006). In Pershing, J.A. (Ed.), *The Handbook of Human Performance Technology* (3rd ed.), (pp. 35–54). San Francisco, CA: Pfeiffer. (2006). Reprinted with permission.

The four key quadrants are:

■ Structure—the foundation of the organization

■ Motivation—the emotions, desires, and psychological needs that incite action

■ Environment—the external and internal conditions that affect the growth and development of the organization

■ Learning—the increase of employee proficiency in a given area

The north-south axis looks at employee competence on a scale of 0 (low) to 10 (high). The east-west axis addresses the employee's confidence in her ability to do her job, also on a scale of 0 (low) to 10 (high).

Using the Performance Map. When you and the manager have identified the specific employees(s) who have performance issues, follow these steps:

■ Help the manager determine the identified employee(s) job competence by asking a question such as, "What skills do employees need to complete the job?" Ask your client to rate the identified employee(s) from 0 (no skills/knowledge) to 10 (highly skilled and knowledgeable).

■ Next, determine the employee's level of confidence by probing for examples of accomplishments, behavior, attitudes, commitment, and contributions. You might say, "Tell me about the general attitude of employees toward this job." Again, ask the manager to rate the performer(s). Zero means your client has no confidence in the performer(s) and 10, that the manager has total confidence in the performer(s). You will note that we ask the manager to rate the employee's performance. You may also want to ask the performer(s) these same questions. We often get conflicting responses.

■ Mark the levels for both competence and confidence on the grid and draw the appropriate horizontal and vertical lines to connect the two variables.

■ You have now determined the quadrant in which the two variables intersect. This will help you to diagnose the most common areas of organizational problems or opportunities and prescribe a series of effective solutions. For example, if you identify a structural deficiency, possible actions might include revisiting the mission statement, or developing goals and objectives for the individual or group. Other quadrants will suggest other solutions.

■ Regardless of which quadrant houses the issue, be sure to consider the other three as you work toward a solution. Remember that you are operating in a performance system, and actions taken in one area will impact the others. This is especially important if you have identified the Learning quadrant as the source of the performance issue. If the manager has a confident employee (a high performer) who needs skills and knowledge, you will want to engineer the environment for success so that the employee will continue to perform at a high level.

■ Finally, consider the organization's culture as you identify solutions to ensure that your prescription will do the job without unwanted side-effects. Few elements of organizational life are as influential as culture. Ignore this powerful force at your peril. We know from experience that performance improvement recommendations and implementation plans must be culture-compatible or they will be destroyed. When strategy meets culture, culture always wins.

Like the Total Performance System model, the Performance Map is scalable. It makes visible performance issues that involve just one employee, for example, or an entire work group.

Tip of the Iceberg

Our third tool reminds us of the importance of integrating performance improvement solutions with all related components of the organization's performance system. The Iceberg (Figure 2.2) is a metaphor for much that can go wrong when we start with an assumed solution, at the tip, and create an organizational disaster because we neglect to consider all the layers of the iceberg below the surface (Addison & Haig, 2006, p. 46).

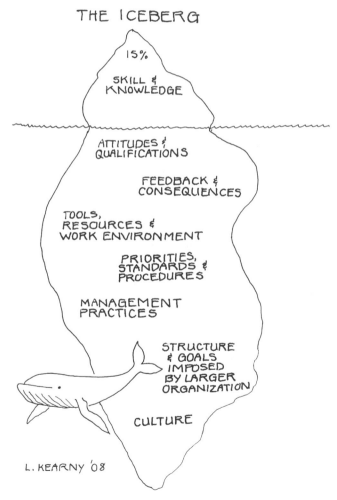

THE ICEBERG

15%

SKILL & KNOWLEDGE

ATTITUDES & QUALIFICATIONS

FEEDBACK & CONSEQUENCES

TOOLS, RESOURCES & WORK ENVIRONMENT

PRIORITIES, STANDARDS & PROCEDURES

MANAGEMENT PRACTICES

STRUCTURE & GOALS IMPOSED BY LARGER ORGANIZATION

CULTURE

L. KEARNY '08

FIGURE 2.2. *The Iceberg.*

Source: Adapted from Harmon, 1984.

Organization Level. The Iceberg encourages us to start our work at the base Organization Level with a Cultural audit so that we get to know the operational norms (Carleton & Lineberry, 2004). With this perspective we can more effectively analyze, diagnose, and prescribe performance improvement solutions that will address the identified concerns and mesh with the organization's business practices. Understanding the environment avoids costly and time-consuming errors. The cultural audit is also a valuable precursor to using the Performance Map we introduced earlier. It is difficult to make and implement recommendations that will align with the business without knowledge of the organization's culture.

Structures and Goals. Moving up the model, we gather information about Structures and Goals—the organizational chart, for example, and such foundational elements as mission, vision, and values.

Management Practices. Next, we explore typical Management Practices. These are related to the culture, of course, and they tell us about the organization's customs and best practices. This helps us understand what is valued in management's performance and will inform how we interact with our client and present our findings.

Priorities, Standards, and Procedures. At this point, we narrow our focus to the Work level as we look at Priorities, Standards, and Procedures. Here, we are interested in work processes, hand-offs, and the connections among work groups as tasks are performed.

Tools, Resources, and Work Environment. To be successful, workers require support in the form of Tools, Resources, and Work Environment. We want to learn about these to ensure that employees have what they need to do their jobs effectively.

Feedback and Consequences. And of course, workers need to know how they are doing, so we look next at the systems in place for Feedback and Consequences. Without these, employees are deprived of critical information about the quality and quantity of their work, and their motivation to perform is undermined.

Attitudes and Qualifications. Finally, we have reached the Worker level, where we explore the Attitudes and Qualifications the organization looks for to select employees. Are these in alignment with all the other aspects represented in the Iceberg? If not, identifying the disconnects will yield valuable clues to the sources of issues and their possible resolution.

Skills and Knowledge. And so we reach Skills and Knowledge at the tip of the Iceberg—the place where many clients begin their request for help from performance improvement specialists. Learning and skill building live here and are vital interventions for situations in which employees do not know how to perform. Organizations should provide activities in this sector to orient new hires or to introduce new products and services, systems, equipment, or other innovations. For all other circumstances, as the Iceberg has shown, the performance issue is at another level and the solution will be found nearby.

OTHER MODELS AND TOOLS

There are many models and tools available to performance improvement practitioners; we offer these as samples from among many we have found useful over the years. They are not meant to be all-inclusive. They allow us one view of organizations. However, no matter how appropriate the tools

are for the task, they are useless to us and to our clients without the all-important link to the organization's business. A colleague reminds us (Wittkuhn, 2004) how important it is to know what our models tell us as well as what they do not say, for once we select a model we may have biased the outcome of our project.

Troubleshooting the Human Performance System

Another tool we have found useful in diagnosing performance issues and opportunities at the Worker level is the Troubleshooting the Human Performance System Job Aid (Figure 2.3). In it, Geary Rummler identifies six areas to consider when diagnosing performance issues: Performance Specifications, Task Support, Consequences, Feedback, Individual Capacity, and Knowledge/Skills.

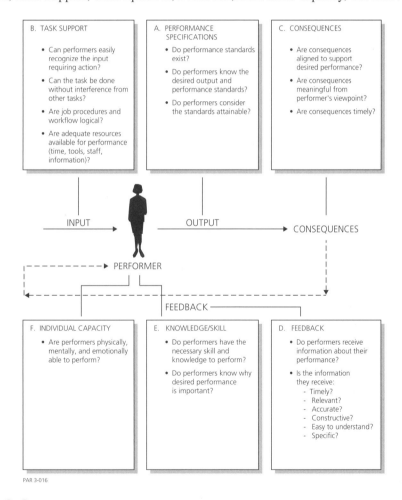

FIGURE 2.3. *Troubleshooting the Human Performance System Job Aid.*

Source: Copyright © 2004. Geary A. Rummler and the Performance Design Lab. Used with permission.

Performance Specifications. The first step is to identify what is expected of the employee:

- Identify and set clear performance expectations

- Check to make sure that the employee knows the desired outcome and what is expected

- Ask the employee whether the expectations are attainable

Task Support. Step 2 is to make sure the employee has the tools and resources required to do the job. Make sure that:

- The employee can easily recognize the required action

- Each task can be completed without interference from other tasks

- The job procedures and workflow are logical

- All tools and resources, including time, equipment, personnel, and information are available to the employee

Consequences. All jobs have positive and negative consequences. A consequence is *whatever happens to the performer that matters to him or her*, as a result of having performed. Consequences occur after a result and produce an outcome. We have seen many managers ignore or fail to communicate to the employee the consequences of doing a good job or a bad one. If an employee does a good job, he is often given more work. If he does the work badly it is often passed on to capable employees known to complete high quality work. It is important to:

- Design the consequences to support the desired performance

- Make the consequences meaningful to the employee

- Make sure the consequences immediately follow work completion

Feedback. We all know feedback is important, but many managers seem to neglect it. Feedback provides valuable information about how an employee is performing and guides his future performance.

- Give feedback to employees about their performance

- Make sure the feedback is timely, relevant, accurate, constructive, and specific to the work performed

Individual Capacity. Capacity is the ability to perform or complete a task successfully. It includes talent and ability. For example, hiring people to provide good customer service who do not have good people skills is a path to failure. Be sure the employees have the physical, mental, and emotional capacity to perform the job.

Knowledge and Skill. Having the knowledge and skill to get a job done is different from having the capacity to do it. Employees need to know what to do and how to do it. The manager's responsibility is to:

- Identify why specific knowledge and skills are important to the successful completion of the job

- Provide an environment in which the employee can develop the required knowledge and skill to be successful on the job

Organizing Troubleshooting Information. To accompany the Troubleshooting the Human Performance System Job Aid we have been exploring, Table 2.2, The Human Performance System Analysis and Improvement Guide, is a valuable organizing aid. We have used it as a checklist for ourselves to assess the information we know going into a performance analysis and to add to as we learn more. The Guide asks questions that enable us to:

- Identify the performer

- Identify the situation

- Identify the desired performance

- Identify the undesired performance

- Review each Human Performance System (HPS) Component: Outputs, Inputs, Consequences, Feedback, Performer, and the characteristics of the ideal HPS

- Answer each troubleshooting question. If YES go to next question, If NO, what will it take to get a yes answer? What additional information will you require?

- Compete HPS Improvement Actions and next steps

SOLUTIONS: TYPICAL EXAMPLES AT THE INDIVIDUAL LEVEL

Once an issue has been diagnosed, it is time to identify appropriate solutions. When working at the Worker or Individual level, it is tempting to suggest training as a solution. After all, if someone is not performing to standard, it must be because the person doesn't know how. While indeed, the performer may require specific skills due to a lack of experience, as we have seen, there are many reasons why someone's work may need to improve. It is therefore more likely that we would recommend a "basket" of solutions that includes a training component. Typical solutions for the Worker level are:

- Setting expectations

- Feedback systems

- Rewards and consequences

- Job aids

- Electronic performance support systems

- Coaching and mentoring

- Information and communication systems

- Clinics and workshops

- On-the-job experiences

TABLE 2.2. The Human Performance System Analysis and Improvement Guide

HPS Components	Characteristics of the Ideal HPS	HPS Troubleshooting Questions and Answers				HPS Improvement Actions
		Questions	Yes	No	?	
OUTPUT	Adequate and appropriate criteria (standards) with which to judge successful performance	A. PERFORMANCE SPECIFICATION				
		1. Do Performance Standards exist? (If "yes", complete Items 2 and 3.)				
		2. Do performers know the desired output and performance standards?				
		3. Do performers consider the standards attainable?				
INPUT	1. Clear or sufficiently recognizable indications of the need to perform	B. TASK SUPPORT				
		1. Can the performer easily recognize the Input requiring action?				
	2. Minimal Interference from incompatible or extraneous demands	2. Can the task be done without Interference from other tasks?				
		3. Are the job procedures and workflow logical?				
	3. Necessary resources (budget, personnel, equipment) to perform	4. Are adequate resources available for performance (time, tools, staff, information)?				
CONSEQUENCES	1. Sufficient positive consequences (incentives) to perform	C. CONSEQUENCES				
		1. Are the consequences aligned to support desired performance? (If "yes", complete Items 2 and 3.)				
	2. Few, if any, negative consequences (disincentives) to perform	2. Are consequences meaningful from the performers' viewpoint?				
		3. Are the consequences timely?				

Desired Performance:

Undesired Performance:

Performer: _____

Situation/Input		
FEEDBACK	Frequent and relevant feedback as to how well (or how poorly) the job is being performed	**D. FEEDBACK** 1. Do performers receive Information about their performance? (If "yes", complete Item 2) 2. Is the Information they receive: 　a. Relevant? 　b. Timely? 　c. Accurate? 　d. Specific? 　e. Constructive? 　f. Easy to understand?
PERFORMER	1. Necessary understanding and skill to perform. 2. Capacity to perform, both physically and emotionally 3. Willingness to perform (given the incentives available)	**E. KNOWLEDGE/SKILL** 1. Do the performers have the necessary skills and knowledge to perform? 2. Do the performers know why desired performance is important? **F. INDIVIDUAL CAPACITY** 1. Are the performers physically, mentally, and emotionally able to perform?

Source: © Geary Rummler and the Performance Design Lab. Used with permission.

EVALUATION

Regardless of the models and tools we use, seasoned performance improvement professionals position our work in the context of critical business goals, requirements, or initiatives, and clearly tie what we do to one or all of these.

Identify the Business Requirements

We begin with the end in mind by learning from the client what critical business, process, or individual issues are of concern and how improved performance can impact what the client identifies as most important. This is what the client values, and to call out these elements at the beginning of an engagement is a hallmark of success in performance improvement. One colleague begins every project by identifying the related business requirements and posting them at his desk as a reminder throughout the engagement (in conversation with Lane, 2004).

Evaluation Planning

With the business need clearly identified, we move ahead with the performance improvement project and plan what and when we will evaluate. This advance planning is key to successful evaluation. Legions of practitioners wait until implementation to go hunting for baseline information to compare to results. Then they attempt to evaluate those results only to discover the near impossibility of doing so at the end of the project.

The best to time plan how you will evaluate a solution is when you and your client agree on the action(s) to be taken. Experienced performance improvement specialists design evaluation to:

■ Show that the solution closes the identified performance gap

■ Relate to the business requirements

■ Have value and meaning for all groups that have a stake in the performance issue

■ Compare results to the baseline information collected at project inception

Formative Evaluation. Successful performance improvement initiatives usually include formative evaluation in the project plan. Wise performance consultants evaluate their projects at each milestone—a practice that keeps everyone on track and helps to identify any needed revisions early so that they can be made before additional expenses are incurred.

Summative Evaluation. This is the evaluation that determines whether or not a solution will be implemented, revised, or discontinued. It is usually conducted at the conclusion of the pilot or after a limited implementation. It marks the "go/no go" decision point.

Return on Investment. Finally, we want to provide our client with meaningful measures to show that the investment the organization made to improve performance has paid off. If we accurately identify the Critical Business Issue (Rummler, 2004) at the organizational level, the Critical Job Issue at the worker or individual level, and/or the Critical Process Issue at the work or process level, we will have the necessary metrics to measure success.

APPLICATION EXERCISE

Now you try it. Select one of the models or tools below to map the workers using these guidelines:

If . . .	Then . . .
You need a clear view of the enterprise landscape	Create a Total Performance System Map, Table 2.1
You would like to get your management and clients involved in the performance improvement process	Walk them through the Performance Map, Figure 2.1
You need to troubleshoot the human performance system	Use the Troubleshooting Job Aid, Figure 2.3

CONCLUSION

The Individual Level is only one of three levels in an organizational performance system. It is often the place from which many performance consultants launch their careers. The prevailing action is an episodic approach to solving a performance issue. That is, some event in the organization triggers a request. Often, the request includes a proposed solution to the problem or opportunity. For example, if back injuries on the job are on the increase, the client may ask for a "safe lifting of heavy objects workshop." Our approach is to take a look at what is going on first and to do a little analysis to diagnose the problem. We often find aspects of the same issue at the various organizational levels. For this reason, we favor an integrated approach to problem solving and maximizing opportunities in an organization. The tools and models we have presented here can be used both to discover the issues and to build performance systems; aids for the detective and the architect. In Chapter 3, The Work: Process/Practice Level, we explore the second organizational level.

WHERE TO GO NEXT

AUTHORS' PICKS

Here are some recommended additions to your library.

Library Additions

Brethower, D.M. (2007). *Performance analysis.* Amherst, MA: HRD Press.

Brethower, D., & Smalley, K. (1998). *Performance-based instruction: Linking training to business results.* San Francisco, CA: Pfeiffer.

Brinkerhoff, O. (2003). *The success case method: Find out quickly what's working and what's not.* San Francisco, CA: Berrett-Koehler.

Broad, M.L. (2005). *Beyond transfer of training: Engaging systems to improve performance.* San Francisco, CA: Pfeiffer.

Gilbert, T F. (2007). *Human competence: Engineering worthy performance.* San Francisco: Pfeiffer.

Harless, J.H. (1970). *An ounce of analysis: Is worth a pound of objectives.* Newnan, GA: Harless Performance Guild.

Langdon, D.G. (1998). *The new language of work.* Amherst, MA: HRD Press.

Langdon, D.G. (2000). *Aligning performance: Improving people, systems, and organizations.* San Francisco, CA: Pfeiffer.

Mager, R.F. (1997). *Analyzing performance problems: Or, you really oughta wanna—How to figure out why people aren't doing what they should be, and what to do about it* (3rd ed.). Atlanta, GA: Center For Effective Performance.

Mager, R.F. (1999). *What every manager should know about training: An insider's guide to getting your money's worth from training* (2nd ed.). Atlanta, GA: CEP Press.

Rossett, A., (1998). *First things fast: A handbook for performance analysis.* San Francisco, CA: Pfeiffer.

Stolovitch, H.D., & Keeps, E.J. (2004). *Training ain't performance.* Alexandria, VA: American Society for Training and Development.

Van Tiem, D., Moseley, J., & Dessinge, J.C. (2000). *Fundamentals of performance technology: A guide to improving people, process, and performance.* Silver Spring, MD: International Society for Performance Improvement.

CHAPTER

3

THE WORK: PROCESS/PRACTICE LEVEL

At the start of a meeting about the declining performance of the three hundred customer care managers in the field offices of a statewide insurance company, the attending stakeholders "knew" that the customer care managers lacked skills and knowledge and required training. By the meeting's end, they were not so sure. The presenting problem was that the customer care managers could not delegate, but during discussion several concerns unrelated to skills and knowledge surfaced.

The two performance consultants attending the meeting quietly gathered information for further investigation. Not surprisingly, several issues arose from the work that the customer care managers were responsible for, such as certain lower-level tasks usually performed by an entry-level employee. Since so many field offices were short-staffed, many customer care managers were simply doing this work themselves because they found it faster than showing an employee how to do it.

Typically, customer care managers were responsible for customer service research such as locating a missing policy payment or comparing coverages available among several policies. In recent years, operational processes like these had been removed from the field offices and centralized into regional processing centers to provide faster results and gain economies of scale. The processing centers had service level agreements (SLAs) with the field for the tasks they performed, but they were missing their deadlines regularly. Many customer care managers had faced irate customers because some research took longer in the processing centers than it had in their offices, and in frustration, these customer care managers conducted duplicate research simply to serve their customers better.

The customer care managers were working extensive hours, doing simple tasks best handled by junior staff, duplicating complicated research work in the name of customer service, and struggling to keep up with their own work while trying to fill staff vacancies. No wonder they were burning out and taking stress leave for extended periods.

The two performance consultants reached agreement with the stakeholders to conduct a full-scale analysis of the situation with a focus on work, process, and practices issues. They named the project Service Fitness and went off to plan their analysis.

They began by compiling a list of the issues they had heard about in the meeting:

- Duplicate research activities in field offices and processing centers

- Customer care managers working extensive long hours

- Number of customer care managers out on stress leave

- Numerous customer complaints

The consultants further assumed that the customer care managers experienced considerable task interference because they were doing so many tasks in addition to their regular responsibilities. They identified the processing centers' inability to meet many of their SLAs as a "Critical Process Issue," flagging this as a potential driver of other difficulties the customer care managers were experiencing.

Mapping the field and processing center organizations was the next step the consultants chose. They wanted to see where the work of these two groups intersected and to understand how they were staffed and managed. Finally, the consultants planned a data review and visits to field offices and processing centers to gather information and observe work processes and practices first-hand. They thought that the combination of all these activities would give them a complete understanding of the issues facing the customer care managers.

SUMMARY OF THE TECHNOLOGY

At the Work Level, performance improvement professionals develop maps of how work is done and identify the supporting work practices. Partnering with our clients and colleagues, we use these maps to make the work processes and practices visible. At this level, we work with subject-matter experts and the people who are doing the work. We observe employees on the job in their work environment. We watch how they perform tasks, interact with co-workers and customers, use tools and resources, and solve problems.

It is important to use what we have learned about the Worker (see Chapter 2: The Worker: Individual/Team Level) as well:

- The performance that is expected

- Feedback systems in place

- Incentives offered

- Consequences of good or poor performance

■ Skills and knowledge required

■ Job fit

The Workplace, both environment and culture, is also a consideration. Chapter 4: The Workplace: Organization Level provides the tools and resources for an Organization Level assessment.

SIGNALS THAT POINT TO PROCESS/PRACTICE LEVEL PERFORMANCE ISSUES

Signals that there are performance issues at the Process/Practice Level include:

■ Products and services are slow getting to the customer

■ Customer and employee complaints

■ Excessive overtime

■ Production bottlenecks

■ Process delays

■ Duplication of activities

■ Rework

■ Back-up systems fail or are not in place

■ Manual verification of automated processes

■ Task interference

■ High turnover

■ Increase in accidents

■ Safety violations

■ Procedures not being followed

As a detective, looking for these clues can lead you to process and practice work issues.

APPROACH

We have found that the observation skill is key for the performance improvement professional. If you can spend some time doing the work you are investigating, so much the better. You may be tempted to interview the worker or the supervisor, or review job descriptions and assume you have a sense of what the work entails. However, we caution you about the limitations of this approach. When you ask people about their work, they tell you what they think the job is or how it has been explained to them. When you observe them doing the work, you will see what is being done and hear what is being said—both process and practice. The combination of researching the work and then seeing it done will help you identify the critical processes and practices for the work.

Before we go further, let's consider some of the questions you may have about processes and practices:

- What is a process?
- What is a critical process issue?
- What is a practice?

Process

A process is a series of actions or "a series of planned activities that convert a given input into a desired output" (Rummler, 2004, p. 167). Further, a "process is a construct or artifice for organizing work" so it:

- Can be performed effectively and efficiently
- Offers the potential of a competitive advantage
- Can be measured effectively

(Rummler, 2005)

In most organizations, there are two types of processes: those that support the enterprise like human resources (HR) processes and financial processes, and critical processes that touch the customer in some way like sales, shipping and delivery, or billing processes.

Critical Process Issue

A critical process issue is "a problem or opportunity related to the performance of a specific process. Examples include 'excessive time to get a new product to market' and 'deteriorating customer satisfaction with time to receive orders.' The critical process issue must subsequently be refined to a specific gap between current and desired results" (Rummler, 2004, p. 163).

Practices

For the performance improvement professional, practices are patterns of behavior and often represent the values side of an organization. We see this as part of an organization's culture. For years, many of us with engineering and behavioral backgrounds found the concept of organizational culture difficult to characterize and observe. There was no standard definition for it and, until the 1980s, culture referred to nationalities rather than organizations.

In 1983, a *Fortune* article suggested that culture is "shared values (what is important) and beliefs (how things work) that interact with an organization's structures and control systems to produce behavioral norms (the way we do things around here)" (Uttal, 1983, p. 29).

And then companies such as IBM began defining culture in their own terms:

"Business practices are the rarely documented how that propels what people do. They are patterns of behavior and actions—an inertial guidance system, so to speak – shared across the organization. They are often communicated to new people by someone 'showing them the ropes.'"

Source: Moulton Reger, Sara. (2006, p. 90). Reprinted with permission from Pearson.

Practices are observable, measurable, and comparable. Process/practice analysis and solutions must address both critical process issues and practice issues. In addition, they must address the supporting processes and practices. In Chapter 2: The Worker: Individual/Team Level, we introduce the Iceberg Model (Figure 2.2) and suggest that a cultural due diligence audit be conducted. One of the best resources for this is the book *Achieving Post-Merger Success* (Carleton & Lineberrry, 2004).

MAPS: MAKING IT VISIBLE

Before traveling to new lands, it is helpful to view a map of the area we will visit. Maps are visual representations that can show interrelationships and help us navigate the who, what, where, why, and how and of the enterprise. The functional organization chart (see Figure 3.1) is the most familiar organization map. It shows us the "who" and the reporting relationships. However, the map shows nothing of where the power is in the organization and it leaves out the customer.

FIGURE 3.1. *Organization Chart.*

It is not until we refine our maps that we begin to know how the enterprise looks. In this section, we will share some maps that have helped us learn the lay of the land in organizations. For detectives, maps offer clues to performance issues and for architects they help in the design of new processes and suggest new practices. The first map we will look at is a culture map.

Culture Map

A culture map is a view of the key elements of an organization's social system. This is valuable information for performance improvement sleuths because culture is at the core of all social systems (Gharajedaghi, 1999, p. 16). Culture maps depict the organization, what the enterprise looks like, and we can start to make out the organizational landscape. A culture map clarifies the visible landmarks and helps less clear areas become evident. A full culture map will look at both the operational and cultural sides of an organization. The cultural elements are shown in Table 3.1. (See Chapter 4: The Workplace: Organization Level for the operational side.)

TABLE 3.1. Elements of a Culture Map.

Cultural Element	Add Your Findings Here in Words or Pictures
What is the organization's overall vision, mission, strategy, values, beliefs, and management practices?	
What are the required results?	
What is the relationship between line and staff employees? ■ Alliances ■ Coalitions ■ Drivers	
How are power and status recognized in the organization? ■ Structure, top down or bottom up? ■ How are tasks delegated?	
What alliances and coalitions exist in the organization? ■ What are their drivers?	

Cultural Element	Add Your Findings Here in Words or Pictures
How are policies and procedures communicated to the employees?	
What communication systems support the organization?	
What formal and informal motivational systems support the organization?	
What is the corporate and branding identity of the organization?	
What does the physical workspace look like?	
What stories and legends exist in the organization about workers, work, and the workplace?	
■ How are these used to drive performance?	

For best results, have an external consultant work with internal performance improvement staff when they gather the information to complete a culture map. The power of this map is to present a view of the landscape, show relationships, and to enable the performance practitioner to see how things are done. In Chapter 4: The Workplace: Organization Level, we explore a subset of organizational culture, its political side, and the relationship between power and influence.

To sum it up, "Like organizational practices, cultural practices are the product of culture selection. That is, practices are more likely to endure if they contribute to the survival of the group (or the customer's organization) through cost-effective production of essential materials goods or services" (Malott, 2003, p. 29).

Flowcharts

In 1921, Frank Gilbreth introduced us to the flow process chart. His charts were the first attempts to find the most efficient way to complete a task. A flowchart is a picture or diagram that represents the elements of a process. Some of Gilbreth's best-known work involved bricklaying. By paying close attention to the work of a bricklayer, Gilbreth was able to reduce the number of steps required to lay bricks from eighteen to five, increasing productivity and decreasing fatigue.

Flowcharts help us visualize work processes and make it easier to spot flaws. Flowcharts help us streamline work. To make the process clear, a series of standard symbols (shown in Figure 3.2) is used in flowcharts.

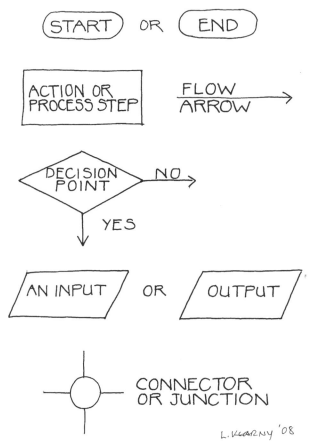

FIGURE 3.2. *Flowchart Symbols.*

To develop a flowchart:

- Gather information on the flow of the process through observation, asking questions, and experience (See the first section of this chapter and Chapter 2: The Worker: Individual/Team Level for more about observation)

- Develop a draft of the flow process

- Review the process with an expert

- Make changes if necessary

- Complete the final flowchart

A sample of a simple flowchart is shown in Figure 3.3.

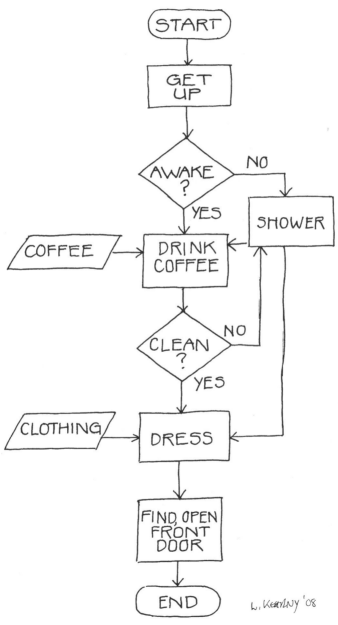

FIGURE 3.3. *Simple Flowchart.*

Figure 3.4 is another way to look at a flowchart:

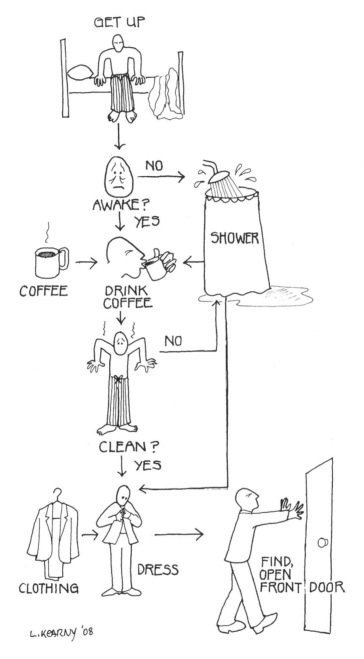

FIGURE 3.4. *Flowchart Graphic.*

There are many tools on the market that will assist you in developing flowcharts. The reference tools in Microsoft Office have a set of symbols you can use to develop your charts. You can draw flowcharts in Word and PowerPoint (http://office.microsoft.com/en-us/word/HA010552661033.aspx). Amazon.com has over three hundred resources on flowcharts, and there are a number of software programs you can use to develop flowcharts. Some sites to visit are:

- Mind Tools: http://www.mindtools.com
- RFFlow: http://www.rff.com
- SmartDraw: http://www.smartdraw.com
- Systems2win: http://systems2win.com
- OmniGraffle: http://www.omnigroup.com/applications/OmniGraffle

Time and Motion Workflow

Time and motion workflow combines the work of Frederick Taylor and Frank and Lillian Gilbreth. The purpose was to study the time it took to complete a task and the number and type of motions used to increase productivity. We were introduced to this approach several years ago when we were trying to increase business efficiencies in a company. We mapped out some of the basic jobs using a workflow chart. We were interested in how we could save time and streamline specific tasks. We collected time and motion workflow information using a generic workflow chart like the one in Figure 3.5.

FIGURE 3.5. *Workflow Chart.*

To complete a workflow chart:

1. Identify the workflow to be charted.

2. State whether you are observing a person performing the work or the work being processed on paper or by computer. Tip: Record the observation steps for a person on a one workflow chart and the steps for a process on a separate workflow chart.

3. Indicate whether you are documenting the current or an improved method.

4. Describe each step of the process. Tip: Use the active voice to describe a person doing the job, for example, "Mary Ann lifts the dish." Use the passive voice to describe a paper or data entry, for example, "The insurance document is filed."

5. Classify each step as follows:

 - Operation: Work is accomplished, information is given or received.

 - Transportation: Something is moved, usually more than three feet.

 - Inspection: Something is read, reviewed, examined, or confirmed.

 - Delay: Record if wait time is longer than thirty minutes.

 - Storage: Something is filed, stored, removed.

6. Enter the distance in feet the worker or object (paper) moves.

7. Enter the quantity; the amount being processed.

8. Enter the time, in seconds, required to complete each step.

9. Identify any possible improvements in the step.

10. Motion: Total the number of times each symbol appears, to assist you when you compare the current and improved process.

11. Time: Total the time (seconds) and divide by 60 to find total minutes.

 The purpose of a workflow chart is to make the process used visible and to discover how much time it takes to complete the task. We can then see what we need to change, eliminate, or do differently. As with many tools, the workflow chart has its limitations. It follows either tasks or paper; however, it does not give a complete picture of the process in the context of other functions that may contribute to the successful completion of the total process.

Swim Lanes

One of the most useful tools for making processes visible is the "swim lane" flow diagram. Swim lane diagrams are arranged so that processes and decisions are grouped and then placed in lanes, one lane for

each person, team, sub-process, or function. These charts show the interactions of all processes within the system. They are useful for tracking processes across an organization, letting us see business processes that involve more than one function or department. Swim lane diagrams let us know who is responsible for the steps in the process and help us spot the delay points and bottlenecks, as well as how long steps take and where mistakes are most likely to occur. An example is shown in Figure 3.6.

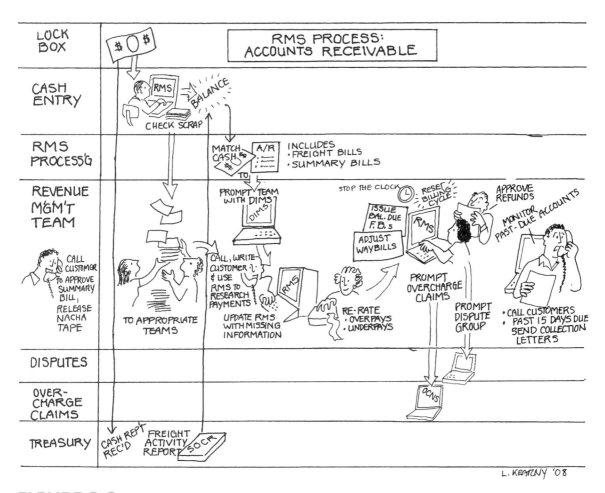

FIGURE 3.6. *Sample Swim Lane Diagram.*

Day in the Life

For thousand of years, storytelling has been part of the human experience. "Once upon a time in a land far, far way" is familiar to many of us. In his book, *The Hero with a Thousand Faces,* Joseph Campbell illustrates the basic ingredients of stories and myths across culture and time, providing a useful backdrop for the value of stories in organizations (Campbell, 1972).

The day in the life approach is a way to tell stories about the workers, work, and workplace. This type of story illustrates what we do and how we to it and is relevant in today's organizations. "The ability to encapsulate, contextualize, and emotionalize has become vastly important in the Conceptual Age" (Pink, 2005, p. 102).

The first step in creating a day in the life is to develop a storyboard, a series of graphics, illustrations, and images used to display the sequence of a story—like an outline in pictures. The day in the life storyboard takes a timeframe and tells us what it is like from the vantage point of the people doing the work. It not only shows the things they do, but also tells a story about how they feel as they perform the task; the interactions, the environment, the context, the look and the feel of the work. Figure 3.7 shows someone creating a day in the life storyboard.

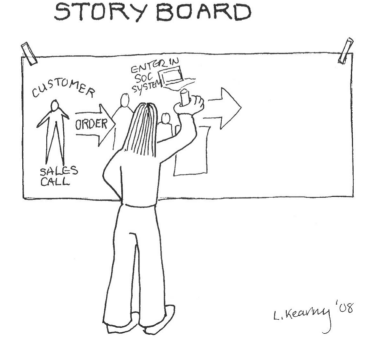

FIGURE 3.7. *Day in the Life.*

PRACTICES: THE MISSING LINK

Most of this chapter has focused on making processes visible so we can streamline and improve them. In the workplace, we have increased our ability to improve business processes. Six Sigma and "lean manufacturing" have afforded many methods and tools to aid us. However, even as the processes improved how work is accomplished, in many cases performance has not improved. In some situations, performance has actually decreased. What is the problem?

Ten years ago, one of us started shopping at his local grocery store. The prices were higher, but the store was convenient. Over the years, the consultant noted that he always went to the same people to check out and avoided others. He stood in line, put his items on the magic belt, the checker ran the items through the magic eye, the total rang up, he gave the checker a credit card or cash, someone asked "paper or plastic" and put the items in paper bags, and he left the store. The process was the same. The difference was in what the checker did. The checkers our consultant avoided did not seem to recognize who he was. Those checkers took his money and rarely thanked him for his business. The checker he would wait in line for asked the consultant how he was doing, said it was nice seeing him again, and thanked him for shopping there. The process was the same. The difference was in what the checker did, her practices.

When an organization's cultural practices, the way we do things around here, are aligned and in harmony with its processes, then we see an increase in the performance coefficient.

In 1994 Don Tosti and Stephanie Jackson suggested an organizational alignment model that would increase our understanding of the alignment between strategic process factors and cultural practice factors (see Figure 3.8).

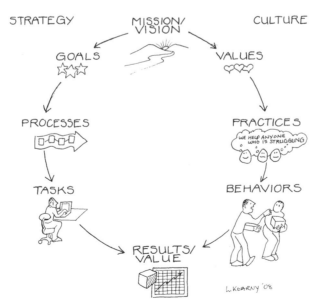

FIGURE 3.8. *Organizational Alignment Model.*

This alignment model can be used to troubleshoot an organization that isn't really producing desired results, even though the strategic factors seem to be in place. Alignment is critical to any system, any organization, any automobile, or the human body. If the Worker, Work, Workplace, and the World are not aligned, we will not produce the desired results. Thus, "the primary management function, then, is to ensure alignment across levels" (Tosti, 2003, p. 1).

A manager's job is to support the organization's mission by identifying the goals, processes, and tasks to support and produce the results. In addition, the manager identifies the values, practices, and behaviors necessary to support and achieve those results. To increase performance and solve performance issues, it is important to consider the Worker, Work, and Workplace. Results depend on both the processes—what we do, and the practices—how we do the job. "Even with well-designed processes, the behavioral practices of groups and individuals can make the difference between merely adequate results and outstanding results. In the worst case, poor practices can destroy good processes" (Tosti, 2003, p. 2). Here is the full text:

"How do you determine the desired strategic processes and cultural practices?

"First, identify the desired results. Then work backwards to determine the tasks, processes, and goals to support and achieve them. Do the same for the other side of the Organizational Alignment model, working backward to determine the behaviors, practices, and values that needed to support and achieve the results."

© 2003 Donald A. Tosti and Vanguard Consulting, Inc. Used with permission.

Following this logic, we can use a reversed alignment model to start with the results we want and plan how to get them by aligning upward. A reverse model is shown in Figure 3.9.

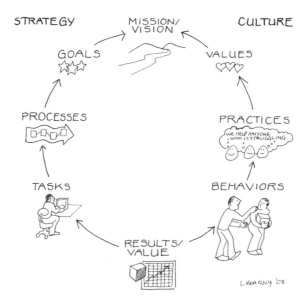

FIGURE 3.9. *Reversed Organization Alignment Model.*

APPLICATION EXERCISE

Now you try it. Select one of the models or tools from this chapter to map your practices or processes or both using the following guidelines.

If . . .	Then . . .
You do not know the elements of the organization's culture and how they drive performance	Create a Culture Map
You need to see the reporting relationships in an organization	Create an Organizational Chart
You need to know the flow of a process	Create a Flowchart
You need to know the interaction of time and motion for a process	Create a Workflow Chart
You need to track the interactions of a process and its functions	Create a Swim Lane Chart
You need to align the organization's processes and practices	Create an Organizational Alignment Chart

We recommend that, when you want to make the work level visible, use more than one method for your discovery.

CONCLUSION

We use detectives and architects throughout this book to relate the investigative aspects of those roles to the analysis work that performance improvement folks do. The tools discussed in this chapter can be employed by both roles. In our detective role, they help us find clues, and show us what is working, what is not working, and the bottlenecks, delays, and unnecessary steps in a process. As architects, they provide blueprints for building total performance systems. When designing a total performance system, both processes and practices become important. The added value for the performance improvement specialist is the integration of the various performance groups in the enterprise to point them toward one over-arching goal: the improvement of the Total Performance System.

WHERE TO GO NEXT

AUTHORS' PICKS

Here are some recommended additions to your library and some interesting websites.

Library Additions

Bethower, D.M. (2007). *Performance analysis*. Amherst, MA: HRD Press.

Brache, A.P. (2002). *How organizations work: Taking a holistic approach to enterprise health*. Hoboken, NJ: John Wiley and Sons.

Gano, D.L. (2007). *Apollo root cause analysis: Effective solutions to everyday problems every time* (3rd ed.). Yakima, WA: Apollonian Publications.

Gharajedaghi, J. (1999). *Systems thinking managing chaos and complexity: A platform for designing business architecture*. New York: Butterworth-Heinemann.

Haines, S.G. (1998). *The manager's pocket guide to system thinking and learning*. Amherst, MA: HRD Press.

Harmon, P. (2007). *Business process change: A guide for business managers and BPM and six sigma professionals* (2nd ed.). San Francisco, CA: Morgan Kaufmann Publishers.

Kotter, J.P., & Heskett, J.L. (1992). *Corporate culture and performance*. New York: The Free Press.

Madison, D. (2005). *Process mapping, process improvement, and process management: A practical guide to enhancing work and information flow*. Chico, CA: Paton Press.

Pink, D.H. (2005). *A whole new mind*. New York: Riverhead Books.

Reason, J. (1997). *Managing the risk of organizational accidents*. Aldershot, UK: Ashgate.

Rummler, G.A. (2004). *Serious performance consulting: According to Rummler*. Washington, DC: International Society for Performance Improvement.

Rummler, G.A., & Brache, A.P. (1995). *Improving performance: How to manage the white space on the organizational chart* (2nd ed.). San Francisco, CA: Jossey-Bass.

Senge, P.M. (1990). *The fifth discipline: The art and practice of the learning organization*. New York: Doubleday Currency.

Sterman, J.D. (2000). *Business dynamics: Systems thinking and modeling for a complex world.* New York: Irwin McGraw-Hill.

Trompenaars, F. (1994). *Riding the waves of culture: Understanding diversity in global business.* Burr Ridge, IL: Irwin Professional Publishing.

Websites

Business Process Trends: www.bptrends.com

Performance Design International: http://improving-performance.net

Performance Design Lab: www.performancedesignlab.com

CHAPTER

4

THE WORKPLACE: ORGANIZATION LEVEL

At a meeting of the concerned stakeholders of a statewide insurance company, the discussion about the declining performance of the company's three hundred customer care managers in the field offices surfaced a number of concerns. As a group of long-term, experienced employees, these managers had recently mastered and successfully applied sophisticated productivity improvement techniques. Now, however, they were working long hours to complete their work, struggling to fill open positions, and going out on stress leave. The finance manager who was hosting the meeting suggested that additional training would help the customer care managers.

The two performance consultants who were gathering information asked questions about senior management's expectations for the work performance of these managers, particularly their critical job responsibilities, accountabilities, and impact on company expenses and revenues. The consultants suspected there were unaddressed alignment issues at senior levels of the company that were pushed down and affecting the ability of the customer care managers to work efficiently.

A regional customer care manager, who had worked in a number of the field offices, profiled a typical day for a customer care manager that provided clues to the range of challenges the managers faced. This helped the consultants expand their knowledge of this critical job and cued them to additional areas to investigate. These included issues at the Worker/Individual/Team Level such as:

- Lack of delegation skills
- Staffing needs
- Staff training

At the Work/Process/Practice Level the issues included:

■ Customer care managers staying late to complete lower level tasks

■ Researching customer problems that should be handled in the processing centers

At the Workplace/Organization Level, the customer care managers struggled to help their customers despite the numerous Service Level Agreements that the processing centers were failing to meet.

The performance consultants asked the group what the primary responsibilities of a customer care manager were, how they set and managed work priorities day-to-day, and how frequently they came together as a group in their districts or regions to share concerns, find solutions, and identify best practices.

As the meeting drew to a close, the performance consultants proposed that they conduct a further investigation of the concerns identified in the meeting and return to the project owner, the finance manager, with a comprehensive set of findings and recommendations.

Privately, the performance consultants agreed that the number and variety of issues facing the customer care managers, and the finance manager's continued belief that extensive training was required, presented some serious challenges. They decided to employ a "divide and conquer" strategy that would help align the leadership around the Workplace/Organization Level concerns. With that in place, and further analysis of the issues at the Work and Worker levels, the consultants thought they would be well positioned to make a case for helping the customer care managers through a unique program that would enable a return to their previous high levels of performance.

SUMMARY OF THE TECHNOLOGY

At the Organization level, performance technologists develop a map of how the organization works and how it fits into its business environment. In partnership with our clients, we use the map to assess whether the internal parts of the organization are working together to achieve its goals. We also use the map to assess whether the organization is paying attention to its environment and adjusting to external realities. We may recommend changes in structure, processes, measures, and feedback loops in order to achieve alignment. Projects at this level affect many people and are likely to be highly politicized, so care and political skills are required. Such projects require a sponsor or champion who is highly placed in the organization.

We often find that a project brought to us as a Worker/Individual Level problem such as, "These people need training," or a Work/Process Level problem such as, "We need to improve our order fulfillment process," has to be solved at the Workplace/Organization Level. This is because decisions made at the executive level are often made without considering alignment issues. For example, slow order fulfillment might be due to the way the manufacturing and sales groups are measured: one gets credit for accelerating sales, the other gets credit for keeping costs and labor down. These separate sets of goals may cancel each other out.

Signals That Point to Organization Level Performance

Signals that there are performance issues at the Organization Level might include the occurrence of multiple re-organizations, mergers and acquisitions, or other structural changes. Or the signal might

be a request for an executive development program, or a succession planning protocol, executive team building, or a culture change workshop. While these may be appropriate, we always assess what is happening at the Organization Level first to ensure we choose the right approach.

Changes at the Organization Level often originate in the external business environment, such as the economy, the supply chain, the labor market, or in market trends. We performance improvement professionals can enhance our credibility by keeping up with current events. See Chapter 7, Focus Forward: Trends to Watch, for more on how world events affect our client organizations.

APPROACH

Think of yourself as first a detective, and secondly a diplomat. There is some background information you would prefer to find out without asking anyone directly, in order to establish your credibility as a skillful investigator. For information not readily available through preliminary research, you will ask people questions, as courteously and non-disruptively as possible. Assume you will be dealing with both cooperative and uncooperative witnesses. With that mindset, find the answers to the following questions:

- What is the critical business issue?

- What are the internal parts of the organization, and how do they relate to each other?

- What is going on in the organization's business environment, and how is leadership tracking and responding to it?

Critical Business Issue

"Critical business issues are the threats or opportunities that are most pivotal to the success of the strategy" (Rummler 1995, p. 116). A critical business issue is a business problem, often expressed as a number, stated at a very high level. If it is a critical issue, it is something that threatens the survival of the organization, or something that offers a significant opportunity for growing the business. Typical critical business issues include slipping market share, eroding margins, difficulty sourcing key talent or materials, stock performance, access to new markets.

Most critical business issues are composed of other numbers combined into a single, easy-to-focus-on number like market share or margin. Margin, for example, is income, itself a sum, less cost, which is also a sum of all the expenses of providing the product or service. To improve performance at the Organization Level, identify a critical business issue and use it both to focus your investigation and to frame your recommendations for action. Deconstructing the critical business issue into its component parts can help lead you to where the biggest problems are and provide you with metrics for assessing whether your intervention is working to close the gap.

While you will often be working on a Worker/Individual or Process Level business issue, such as reducing the cost of recruiting and retaining talent, your ability to show how that project affects margin will effectively tie your work to a higher-level critical business issue that senior managers will care about.

Tip: When you work at this level, leadership typically relies on expert consulting resources with wide brand recognition, such as McKinsey or Bain. What experts do the executives in your

organization turn to for advice? It may be wise to reference their publications and techniques when making recommendations or proposing a particular approach.

To look at the organization's internal structure and external realities, performance improvement specialists use environmental and internal scans.

Environmental Scan

Just as we consider the work environment before we can improve an individual's performance, we consider the organization's context before we improve its performance. An environmental scan looks at the big environmental factors in the organization's marketplace. One of several useful models for looking at an organization's context is Michael Porter's environmental scan, which looks at both general and industry-specific factors (Porter, 1998).

General Factors or Trends

- Economic

- Demographic

- Political/legal

- Technological

- Socio-cultural

Industry-Specific Factors

- Whether the industry is shrinking or growing

- How intense the rivalry is between competitors

- What the risk is of new competitors entering the industry

- What the risk is of a substitute making the organization's products and services obsolete, such as MP3 files supplanting CDs

To understand what is driving strategy and decisions for the organization, the performance improvement practitioner needs the big picture of how the organization fits into its industry. We also need to understand the business environment that has created the risks and opportunities the organization faces. It is useful to create a working summary of our findings so we can validate them, and keep referring to them as we work.

Internal Scan

In Chapter 2, The Worker: Individual/Team Level, we emphasize the need for goals and expectations. The same is true at the Organization Level: to assess current performance and target improvements, it is important to know the mission, goals, targets, plans, and strategies in place for reaching the goals.

Performance improvement specialists also map the structure of the organization—not merely with an organization chart, but with a diagram that shows the major divisions of the organization,

such as research and development, manufacturing, and sales, and how they relate to each other. A truly useful map will also show key cross-functional processes and feedback loops.

What are the current challenges, obstacles, and limitations facing the organization? A challenge might be that a significant competitor is bringing products to market faster and at a lower cost. Obstacles could include a shortage of investment capital for expanding a key manufacturing line. A limitation might be stringent environmental regulation in states where the company operates. Create a map or summary of what you learn as an ongoing reference for your work. The section on mapping the organization that follows shows a sample map.

Link to Critical Business Issues

Organization level analyses and solutions must address critical business issues that affect the welfare of the whole organization, like losing market share, missing profit targets, increasing costs, flat revenues, lower pricing from the competition's superior products/services, lower earnings, missed sales targets, or large numbers of unhappy customers (lawsuits, complaints, departures). Other critical business issues include failing a key general audit or incurring regulatory penalties.

Major opportunities and initiatives are also critical business issues. These may be strategic-level, organization-wide initiatives, like a change in market focus, or customer strategy, such as the launch of a "customer-first" initiative. Perhaps a new core product or process is being introduced, like implementing electronic medical records for a large health-care system or an expansion from an international to a multi-national organization.

Often, clients ask for a solution without specifying the business issue. You may have to be persistent to uncover it, but an issue is always there. Identifying the issue and being able to articulate it clearly is key because the issue is both the target and the engine that will power your project.

Preliminary Research

Here are some things to find out about the organization before launching an Organization Level project.

- Check the company's stock price and current news releases for initial context information.

- Make a friend in finance, as we suggest in Chapter 2, The Worker: Individual/Team Level, and ask:

 - What are the important numbers this year, this quarter . . . and how are we doing?

 - What non-financial numbers are part of this year's goals and tracking (market, customer, product/service, process-related)? How are we doing?

 - Given the performance improvement issue(s) you are pursuing, what is the impact on key business metrics for the organization?

- What are the management practices/culture? This means, irrespective of what management says, how they actually operate day-to-day.

 - What behaviors and accomplishments are rewarded, and which are punished?

 - What does or does not fit with "the way we do things around here"?

Organizational Politics

It is not enough to have a good technical plan; you also need a good political plan if you want to get anything done. Politics in organizations is the source of much confusion and angst: it is also the source of power and influence. Politics comes from the Greek word for people, and has the same root as policy. If you have more than two people in a room, you will have politics.

Politics is the process of influencing others to make decisions, support ideas, and advance goals. It is how we really get things done, and is the glue behind the organization chart. The important things to recognize about organizational politics are:

- They are there, they are necessary, and they will never go away

- We need to understand and work with them to accomplish anything in an organization

- If we attempt to ignore or avoid them, we disenfranchise ourselves and doom our projects to failure

In our view, there are two positions people play in organizational politics: destructive and constructive.

Destructive Politics. By destructive politics, we mean people who influence others only to advance their own personal goals and who subordinate everything else to their own interests. This may involve lying, cheating, and undermining others, and it's the reason politics gets a bad name. We believe it is a big mistake to engage in destructive politics, but it would be foolish to claim that it doesn't exist, or that it isn't sometimes successful.

Constructive Politics. By constructive politics, we mean influencing others for the advancement of organizational goals and serving the long-term interests of all. It is our experience that constructive politics is necessary to influence people to change, which is, after all, the objective of improving performance. Sometimes using constructive politics doesn't prevail, but the better you get at it, the more projects you will bring to successful completion.

So how do you succeed at constructive politics? First, it's important to understand where you are positioned in the political landscape. In the organization, or in the part of it you are dealing with, who has power? That power may be formal, due to the person's position, or informal, due to factors such as expertise, personality, reputation, or a strong ability to form alliances. What relationships, both personal and professional, and alliances do those with power have? Who are the decision-makers in the organization, and who are the influencers and advisors they rely on to inform them before they make decisions? The decision-makers are often obvious from the organization chart, but their influencers and advisors are not. We typically uncover this information by asking people, and by observing interactions among members of the organization. Internal consultants have an advantage here—they often already know, or know whom to ask, as may your clients.

Second, identify the political stance of the people with power who are likely to be involved in the change you want to make:

- Spectator—an observer

- Win-Lose Player—a key person who uses destructive political power

- Constructive Player—a savvy person who likely has both personal and position power

This is an important activity because it will enable you to know what kind of responses to expect, and who to work with versus who to work around. You don't want to put a spectator in a key role in an implementation plan, for example. One of us had the unhappy experience of implementing a cross-functional initiative with a win-lose player in a key liaison role. This can't always be avoided, but you want to know what to watch out for and what to lobby for. And while you are evaluating the political positions of key people, what is your own?

Third, develop your influence strategy. This includes both communication and coalition building. Savvy performance consultants plan who to talk to and in what order to gain the ear of those whose cooperation is critical. This technique is referred to later in this chapter as "divide and conquer." If the people you need to influence don't share the same goals, look for a way to bring them together to create a coalition. A good start is to use one-on-one meetings to try out ideas on an individual, and ask, "What do you think?" "Why do you think that?" "What is your position?" and "How do you feel about X point of view?" Once you understand that one key person is really concerned about customer service and another cares about reducing turnaround time, you can pull together a solution that addresses both concerns, and build a coalition of support for your project (B. Lawton, personal communication, July 2008).

Political Mistakes to Avoid

- Don't be a purist. Many projects fail because the person driving them sacrificed the good for the perfect, and nothing was implemented.

- Don't act as if you know all the answers and are there to straighten everyone else out. Show respect for the culture and environment of your client, and for their understanding of the situation. Carefully approach your "truth" bit by bit.

(B. Lawton, personal communication, July 2008)

Political Opportunities to Seek Out

- External consultants are like tourists. As long as they respect the local customs and look more than they talk, they have license to be a little strange and say things that internal people couldn't get away with. We find that partnering with internal consultants can help the externals be more effective while smoothing their way.

- Internal consultants are like native guides. They understand the culture and customs and can offer good advice about who to approach and how to do it. All the authors have at one time been internal consultants. We found that partnering with external consultants helped us deliver messages that would not have been heard had we delivered them ourselves.

Map the Organization to "See" Context. Earlier, we discussed the need for creating a map of the organization's context: its environment and its functions. There are a number of good models for creating your map. Here are four of them. Each will give you a different perspective on the organization. All are very useful.

Geary Rummler's Organization Maps. The Anatomy of Performance is a map of the organization and its super-system (Rummler, 1995). Figure 4.1 shows the organization and its relationships with suppliers, markets, competition, and the economic, regulatory, and business environment. The external part of the super-system includes government/regulation, the economy, and society, the market, the competition, and resources such as capital, labor, suppliers, and expertise. The internal part of the super-system shows the organization's key processes as well as interactions among departments. This will help you, and often your client, see all the elements of a dynamic system that has a powerful influence over everything that happens within the organization, and assess how the elements impact the business issues you are trying to address.

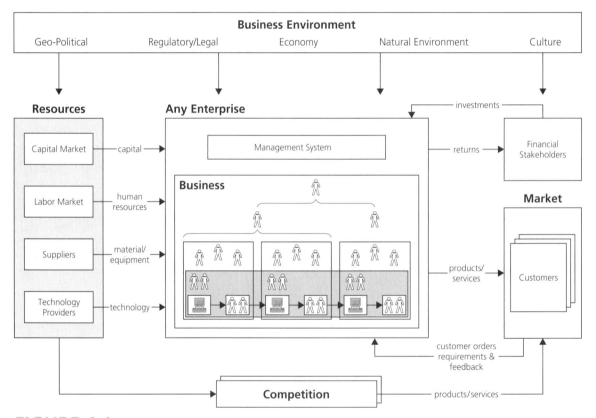

FIGURE 4.1. *Anatomy of Performance.*

Source: ©2008 Geary Rummler and the Performance Design Lab. Used with permission.

Figure 4.2 is another way to view the Anatomy of Performance.

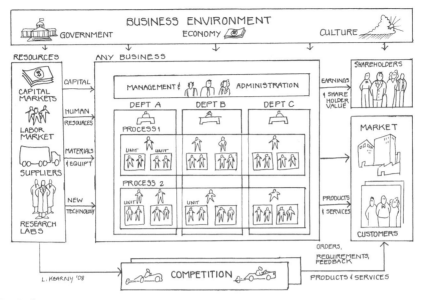

FIGURE 4.2. *Anatomy of Performance Graphic.*

Judith Hale's Performance Consulting Job Aids. We have found Hale's Hierarchy Job Aid an excellent tool for doing a high-level assessment of how well an organization is functioning as a whole (Hale, 1998, pp. 128–131). It works as well with governmental and not-for-profit organizations, as with corporate clients. Table 4.1 shows only the first portion, which addresses congruence and clarity—what we call alignment in the rest of this chapter. The job aid includes:

- A model for reviewing the entire organization

- Questions to find answers for

- Hypotheses to confirm

- Data to collect and how to get them

 The model covers:

- Vision and Mission

- Goals and Objectives

- Values, Incentives, Rewards, and Policies

- Efficiency

In addition, the job aid lists a half dozen other useful areas to investigate. Together the model and the job aid help to assess whether the organization currently has the capacity to achieve its goals, and if it does not, how to build capacity so the goals can be reached.

TABLE 4.1. The Hierarchy Job Aid.

1. Hierarchy model and questions	2. Hypotheses: what to confirm	3. Data to collect	4. How to get data
Congruency and Clarity			
1. *Vision and Mission* A. Are there vision and mission statements? B. Does the mission reflect the organization's current requirements and desires and the environment in which it operates? C. Is there consensus on what the vision and mission are? D. Does the mission support the vision? E. Does the company's long-range plan support the vision and mission?	■ What is the mission? ■ Is there consensus on the mission among all work groups? ■ Who are the customers? ■ How is the mission communicated? ■ Is there a long-range plan? ■ Does the company realize it needs to change?	■ Mission statement ■ What people say the mission is ■ What people say the mission means to them ■ What customers need and how the business responds	■ Written mission statement ■ Written communications to staff ■ Customer satisfaction surveys ■ Market research ■ Stratified random survey of employees ■ Interviews
2. *Goals and Objectives* A. Are the goals congruent with the mission? B. Do they reflect the resources and operating specifics required to progress as a whole? C. Do they exist for each operating unit? D. Do people know what they are? E. Do they follow them?	■ Do the goals and objectives of each department support the mission? ■ Do they agree with one another?	■ Department goals and objectives ■ What people say their objectives are ■ How well resources match objectives	■ Nominal groups ■ Business plans ■ Managers' objectives

TABLE 4.1. *(Continued)*

1. Hierarchy model and questions	2. Hypotheses: what to confirm	3. Data to collect	4. How to get data

Congruency and Clarity

1. Hierarchy model and questions	2. Hypotheses: what to confirm	3. Data to collect	4. How to get data
3. *Values, Incentives, Rewards, and Policies* A. What are the leader's values? B. Are those values known and shared? C. What is the organization's culture, and what specific behaviors does it support? D. Are those behaviors really rewarded? E. What are the rites and rituals? F. Do conditions support what the organization says it values (such as commitment, innovation, compliance, teamwork, individualism, entrepreneurship)? G. Do the company's policies support its values, mission, and vision?	▪ What's important? ▪ How are the values prioritized? ▪ Are the values and rewards congruent with each other and with the company's mission, goals, and objectives? ▪ What are the consequences of nonperformance?	▪ What does success look like? ▪ What does the company measure? ▪ What is a "good" person like? ▪ What is rewarded? ▪ How are people promoted? ▪ Who are the heroes?	▪ Values statements ▪ Customer satisfaction surveys ▪ Sociograms ▪ Reward and recognition programs: - Documentation - Awards - Recipients ▪ Focus groups

Excerpted from Hale, J. (1998). *The Performance Consultant's Fieldbook*. Wiley, 1998, pp. 128–131. Used with permission.

The Balanced Scorecard Job Aid (Hale, 1998, p. 120) is helpful for targeting key business issues at the Organization Level, scoping the problem, and guiding a client to prioritize where to invest limited resources. It also provides good data for measuring the results of a performance improvement project.

Business Logic Analysis. The model in Figure 4.3 shows an external scan with general trends, industry trends, key threats and opportunities, and an internal scan with finance, strategy, customer, product, process, and infrastructure (Kearny & Silber, 2006). It will give you a clear understanding of what the business is trying to do and show how to find the metrics the organization uses to assess how well it's doing. You can obtain the full job aid on the web at www.silberperformance.com under Presentations.

External Logic

THE INDUSTRY

For This Type Of Industry, What Is:

- **The threat of new entrants?** How easy is it for new competitors to enter the market?

- **The bargaining power of suppliers?** Are key suppliers many or few? Are they tightly organized or fiercely competitive?

- **The bargaining power of buyers?** Are there many sources of the customers' products/services, or are they a scarce resource?

- **The threat of substitutes?** How likely is it that the customer's product will be completely supplanted by something different? (Ex: typewriters replaced by computers)

- **The intensity of the rivalry?** How fiercely do firms in this industry compete with each other?

- **Is the industry growing or shrinking? How fast?**

External Logic based on Michael Porter's "Competitive Strategy"

Internal Logic

Economic Logic: Organization's sources of profit & growth

Strategic: Organization's purpose, direction, plans & culture

Customer: How organization identifies, attracts & keeps customers

Product/Svc: How its products/services appeal, how they're differentiated, & image with customers

Process: How organization develops, produces, & delivers its products/services

Internal: Infrastructure – How organization structures itself to accomplish its work

Internal Logic based on Karl Albrecht's "Northbound Train" and Kaplan & Norton's "The Balanced Scorecard"

External Logic

GENERAL TRENDS

What Current Trends Are/Will Be Affecting This Type of Business?

- **ECONOMIC**
 What changes in the economy are impacting the business? Fluctuating interest rates? Availability of capital? Other?

- **DEMOGRAPHIC**
 What changes in the population are affecting the business? Aging population? Labor market migrating? Other?

- **POLITICAL/LEGAL**
 What changes in legislation, regulation or legal precedent is impacting this industry? Rise in lawsuits or awards? Changes in safety or environmental restrictions? Reductions in federal funding? Other?

- **TECHNOLOGICAL**
 What technological trends or innovations are affecting (or are likely to affect) this industry? Electronics? Biotech? Chemistry? What specific developments?

- **SOCIOCULTURAL**
 What changes in people's habits, desires, actions or beliefs are affecting the business? Changes in credit spending? Educational level? Other?

FIGURE 4.3. *Business Logic Model.*

WHAT IS THE GAP: DESIRED VERSUS CURRENT BUSINESS RESULTS

For the critical business issue or its components, what is the desired result—we want a 15 percent market share—and what is the current level—we currently have a 10 percent share. In this example, the gap is a 5 percent share of market. Such a clear and measurable gap helps to scope the problem and determine the value of a solution. Some clients know exactly what gap they are trying

to close, whereas others have a strong feeling or belief that there is a problem but are a bit vague about the goal.

Clients often need help in specifying the gap. Savvy performance consultants find it is critical to success to stick with it and define the gap. The gap lets us identify the value of solving the problem—a 5 percent increase in market share can be converted to dollars quickly—so we can scope our efforts accordingly. It gives us a clear target and a way of measuring results. We find that the gap also points to where to look for a sponsor or champion: look for a person in authority whose goals are threatened by the gap.

Conduct a Requirements Audit for Organizational Results

Once you have identified a gap in performance against results, check whether or not the organization meets basic requirements for achieving and sustaining organizational results. Geary Rummler has identified six requirements that an organizational system must meet to translate plans into predictable, consistent results:

- Is the super-system monitored and appropriate actions taken? (See The Anatomy of Performance, Figure 4.1.)

- Is the organization aligned with the super-system via mission/vision, strategy, business model, and goals? (See also Business Logic, Figure 4.3.)

- Are the value chain outputs and requirements linked to organization and customer requirements, clear, and communicated?

- Are processes optimized to achieve the desired value chain results via aligned goals and capable processes?

- Are the processes capable of achieving the desired results?

The value of mapping the organization and its super-system is that you can organize your analysis around these six factors and find breakdowns fairly quickly.

Is Anyone Already Achieving the Desired Results?

Identify one or more sites, plants, departments, or other sub-groups that are exemplars: achieving the desired results or better. Then, contrast these with similar sites that are producing average results to see what the exemplar is doing that the others are not. This also allows you to determine how much of an improvement is realistic within the client's current system, since at least one of the units is already achieving it.

PROBLEM SOLVING

At the Organization Level, most performance concerns are alignment issues, both internal and external. We are all familiar with how organizations seek efficiency by separating themselves into specialized groups: manufacturing, sales, finance, human resources (HR), and so on. As they grow larger, many separate into further divisions organized by product, market, or geographic area. In very large organizations, to keep the size of each operation manageable, divisions each duplicate their own functional groups rather than compete for the centralized services of one function such as finance or HR. The

unintended consequence is the creation of silos that operate independently, and a fragmented set of leaders, goals and strategies. Chapter 3, The Work: Process/Practice Level, discusses the fragmentation that results when core processes traverse functional lines. The duplication of functions also fragments automated systems, confuses metrics, and drives up operating costs (Herbold, 2004).

Alignment

To pinpoint an organizational performance issue so you can start problem solving, look for alignment issues. Search first for problems with internal alignment. Employees are likely to have noticed them, and are able to talk about them, which makes them easier to spot. It is also important to look externally at whether or not the organization is in alignment with its super-system. Different groups within the organization are attuned to different parts of the super-system. Marketing and sales are aware if the organization is out of alignment with the market. Procurement and manufacturing are usually more sensitive to alignment with suppliers. HR and Legal are often aware of poor alignment with government regulation. We find we usually have to identify alignment issues ourselves, then check our perceptions and add detail by talking to employees.

Internal Alignment Issues. There are four kinds of internal alignment issues:

- Horizontal alignment
- Vertical alignment
- Alignment between organizational goals and organizational activities
- Alignment between the organization's management practices and its goals, strategies, and values

Horizontal Alignment. This means that every part of the organization has goals and strategies that support the goals and strategies of the organization as a whole. All parts of the organization cooperate to ensure that no division, function, or department achieves its own goals at the expense of another group. In organizations with poor horizontal alignment, you will see feudal behavior where each group attempts to maximize its own resources and achievements, often to the detriment of the others. By optimizing its parts, this sub-optimizes the entire organization.

Vertical Alignment. Goals and strategies created at senior levels must cascade down through the organization so that people at each level understand and contribute to the master plan. Some people refer to this as "line of sight," ensuring that each person has a clear understanding of what he or she must accomplish and how it contributes to the whole. There must also be alignment from the bottom up, so that planners and strategists can determine the organization's actual capacity to execute the strategies. This includes time, equipment, skills, and access to required resources. Many organizational initiatives fail because leaders create initiatives that they simply hand off without checking these critical factors.

Alignment of Goals and Activities. Check that organizational goals, strategies, and initiatives are reflected in the daily activities of the organization. Often they are treated as special, one-time projects that interrupt, but do not otherwise impact business-as-usual. The entire point of goals, strategies, and initiatives is to change business-as-usual into a new form.

To illustrate, a consulting firm had a goal to increase sales by 25 percent. Their strategy was to require everyone in a customer-facing position to initiate sales or cross-sell. However, there was nobody in the firm who had professional selling skills, and efforts to provide sales training were always set aside to meet the daily demands of running the business and to handle current customer requests. The only activity that supported sales was a weekly meeting to discuss the pipeline, but it was often cancelled due to busy schedules. While members of the firm often discussed the goal, their day-to-day activities remained out of alignment.

Keeping the organization's goals and strategies in mind, consider what impact they should be having on the ongoing activities of the organization and look for evidence that this is happening. If there is little or no connection between organizational activities and organizational goals, this is a serious misalignment to address.

Alignment of Practices with Goals, Strategies, and Espoused Values. Practices refer to the way people act on a daily basis, their patterns of making decisions and taking action. Practices also refer to the way people habitually communicate and interact with each other. Management practices model the acceptable and expected behaviors. Observing management practices tells both employees and customers more about the organization than any number of newsletters, memos, advertisements and announcements. Read more about practices in Chapter 3, The Work: Process/Practice.

Unfortunately, practices do not always reflect the organization's stated goals, strategies and values, causing misalignment. For example, an organization that states it puts customers first, but consistently under-staffs and under-equips customer service units, is out of alignment, as is a large computer company that had the strategic goal of becoming a "best place to work." In order to attract top talent the company advocated "openness" as a value. However, the executive floor was a luxurious and spacious place nobody below the level of senior officer could visit, workers' cubicles were tiny, and plans for major changes were never announced before the last minute. This lack of alignment made people cynical, and did not encourage them to put forth their best efforts.

External Alignment Issues. As mentioned at the start of this chapter, every organization is part of a super-system. This includes its market, competition, suppliers, and broader factors such as the economy and the legal and regulatory environment. A successful organization must constantly monitor these external factors and adjust to the changes that continually arise. The following must be aligned with the super-system:

The Organization's Business Model, Goals, and Strategy. If the business model assumes constant incremental increases in its prices at a time when the economy is tightening and buyers are cutting back, the model is out of alignment with external reality. If strategy demands rapid acquisition of many skilled and experienced specialists at a time when more of them are leaving the labor pool than are entering, the strategy must either provide the resources for extraordinarily attractive recruitment offers, or it must be brought into alignment with the changing labor market.

The Organization's Value Chain. The outputs of the value chain must be aligned with what the market demands. The functionality, quality, cost, and maintenance of the product or service must match customer requirements. It must not cost too much to produce, and it must conform to any external regulation.

Earlier in this chapter, we looked at tools for examining the organizational context. The Hierarchy Job Aid, Table 4.1, is useful for reviewing and assessing an organization's alignment in all the

areas discussed: horizontal, vertical, goals versus activities, and practices versus goals, strategies and values. This job aid is particularly helpful for doing a systematic review of these areas, which can be diffuse and confusing without a clear guide.

Interpret Your Findings

Review the map you have made of the organization and its context and the notes you have taken while talking to employees. What misalignment issues have you identified? Initial insights are very seductive: we have learned to first confirm or disprove the issues, then narrow to ones we are confident of. Tip: Never generalize conclusions from information you gathered only at corporate headquarters. In our experience it is not only valuable to get the perspective of people in the field, but it is essential.

Build a hypothesis. Based on the information you have gathered, what would explain the current situation? A hypothesis might be that the organization is getting poor results because there is a lack of internal alignment between departments. The managers and their groups are competing with each other rather than working together to best the organization's competitors.

Then ask: What would disprove your hypothesis? What evidence can you find to undermine your current view of the situation? Should you modify your views? For example, you might check into performance for the last few years and discover that the departments worked together very well up until a major acquisition, after which goals and priorities became unclear as the two organizations tried to mesh operations. You might discover that the lack of alignment is between the merged organizations, not departments in general.

Performance improvement professionals test their hypothesis before using it to present a diagnosis; not only to double-check that they are on the right track, but also because it is sure to be challenged and tested by many others, especially at the Organization Level.

We have found that it is very important to partner with our clients during this diagnostic stage. Resist the temptation to go off and do all the interpretive work yourself, then present it as a complete and polished set of conclusions. Engage the client in reviewing the data, then forming and testing hypotheses. It takes time early in the process, but it saves a lot of time later if the client is already on board with the conclusions.

Select Solutions

Next, consider what could be done to close the gap. Who should be involved? Solving problems at the Organization Level is complex. It involves influencing powerful people and is politically charged. Table 4.2 lists some possible solutions that are useful for Organization Level issues. Look through it and identify any solutions that you think will impact the issues you have identified in your hypothesis. Then try to think of other options that aren't listed. Build a list of possibilities. Customize it to the organization and the situation.

The table is only a partial list of options, to get you started.

TABLE 4.2. Solutions Matrix Job Aid.

Appraisal/Feedback	Communication Systems
■ Customer/Client Feedback Mechanisms	■ Corporate Communications Systems
■ Identification of Performance Indicators	■ Virtual Meetings
■ Performance Appraisal Systems	■ Meeting Planning
■ Performance Information Systems	■ Public Relations
	■ Negotiation Systems

Leadership Development	Standards
■ Assessment Centers	■ Internal Contracts, Letters of Intent, etc.
■ Executive Development	■ Service Level Agreements
■ Executive Coaching	■ Guidelines
■ Job Rotation Systems	■ Partnership Agreements
■ Loaned Executive/Job Exchange Programs	■ Policies
■ Mentoring	■ Procedures

Management	Organizational Design/Development
■ Visioning	■ Change Management
■ Strategic Planning	■ Conflict Management
■ Goal Setting	■ Culture Change Programs
■ Marketing Systems	■ Group Dynamics Organizational Rites and Rituals
■ Financial Systems	■ Reorganization/restructuring
■ Performance Management Systems	■ Team Building
■ Succession Planning	■ Values Clarification

Reward/Recognition

■ Benefits Programs

■ Bonus Systems

■ Commission Systems

■ Compensation Systems

■ Incentive and Recognition Programs

■ Merit Award Systems

Adapted from ISPI.

Now that you are dealing with highly political issues, consider partnering with an organization development (OD) expert to build a more robust list of options. A skilled OD consultant will suggest approaches that are more closely linked to emotion, values, interpersonal influence, and "soft" techniques than the hard, "scientific" approaches of HPT. A blend of the two can be very productive. OD practitioners are often more successful at influencing people to change, especially those who may have something to lose.

When you have a built the list, evaluate the items using these guidelines:

■ Which options are the most powerful for obtaining the desired outcome?

■ Which key business drivers will each impact, and what is the likely result?

■ What other key business drivers will be impacted, perhaps negatively?

■ What is the political fit with the organization and the likelihood of adoption?

■ What are costs, time required, and how quickly will the client see results?

Both your client and an experienced OD partner can help you greatly with this evaluation process: the client with impact and metrics, the OD partner with the implementation process and a realistic timeline for adoption of change, and both of them with power and acceptance.

Bedside Manner

The relationships of performance improvement specialists with clients are at least as important as the models we use or our technical know-how and experience. There is no "yellow brick road," no set of steps that will reliably lead us from the start to the finish of an HPT project with success assured. We must be able to adapt what we know to the circumstances and culture of the organization and to the concerns and character of our client. It's like being a chef: you can't just follow a recipe—you have to be able to adjust it to the setting, available resources, conditions, and ingredients. You must also know how to present what you've created, set up the experience, and turn a meal into a banquet.

Here are some guidelines for working with the client as a consultant and a partner to add value though the work you do and the way that you do it.

Divide and Conquer. This is "the meeting before the meeting." Rather than trying to sell a new approach to an old problem in a group setting, partner with your client to identify key stakeholders and opinion leaders. Arrange to meet with each individually to discuss your findings and recommendations, get their input, make adjustments, and solicit their help in bringing others in the organization along.

Find a Champion. Ideally, your client will be in a role that commands authority, influence, and control of funding. If not, partner with him to identify someone who has the needed leverage and a stake in the project outcomes. Work together to recruit that individual as a champion for your project. Suppose your client is a training manager who understands HPT. He brought you in to help with a request for team leadership training that is actually a symptom of an organizational alignment issue. Together you could identify a senior executive who is open to new ways of getting results. You could partner to recruit the executive to act as your champion: to legitimize decisions, move roadblocks, and advocate upward for your work.

Identify the Disconnects. What requirements are not being met? If an organization wants a team-building event for executives, what is happening, or not happening, that causes the requestor to believe team building is needed?

For instance, an insurance firm had a sales group with a "team-building problem." Their goal was to increase sales, and senior management decided this could be done if the sales representatives in field offices only did active prospecting and calling, rather than sitting in the office waiting for prospective customers to call in for a quote. The executives created a new centralized telephone sales force that only responded to customer calls for quotes and followed up on Internet inquiries. All incoming quote calls to offices were switched to a new 800 number, and the change was announced.

This was a good idea. However, the existing field sales organization's goals were not adjusted for the sudden shift in call volume. The entire field sales organization publicly supported the change, but undermined the centralized sales group to make it fail so their own incoming call volume would be restored. The resulting increase in sales was disappointingly low due to the disconnect between the two sales organizations' charters and the way their goals were established.

It was clear to senior management that team building was the answer. The performance consultant helped them see that they could blame the middle and lower levels of sales management and the sales representatives for undermining the initiative, but that the real responsibility was theirs for simply announcing a change and failing to adjust allocation of goals, which only they had the authority to do. Organizational alignment has to start at the level where a decision is made.

Find a Positive Way to Ask Questions. The performance consultant in the insurance company above asked, "Have the goals of the field sales organization changed in any way since the beginning of the year?" rather than, "How were the field organization's sales goals changed to reflect the total absence of incoming calls for quotes?" Think about how the question will be experienced by the person you are asking, especially if she is the decision-maker who put the current procedures in place. Always assume there was an intelligent and positive reason for any action, and frame your questions accordingly. One tip: if any question you want to ask would still make perfect sense if you added the words "you dummy" to the end, rephrase the question.

Keep the Client Informed. To the extent possible, keep the client informed of what you are finding during the research and analysis phase. Avoid surprises, particularly if you discover something that could prove embarrassing to the client in a report or presentation that others will see. Establish a regular check-in time to discuss progress and findings. If you do find risky information, strategize with the client about how best to present it to others.

A colleague discovered that a professional and highly paid group was duplicating procedures at a cost to the organization of $2 million a year. When he shared this privately with his client, the client said, "If you say that, I will lose my job." Together they agreed that the consultant could report that the duplication was costing the organization "over half a million dollars a year." That would be truthful as far as it went, would be enough to move the organization to action, but would not cause the client to be fired. It would also give the client room to solve the problem and exceed expectations by $1.5 million which he proceeded to do.

Prepare to Present Your Findings. Organize your findings and prepare to present them in a summary, visual form. Take care to keep alignment issues salient and visible. We usually put the detail—the methodology, questions asked, data, audiences interviewed, and in-depth findings—as attachments to our summary, or in a separate document available on request. When this is ready,

present your visual summary to the client with your hypotheses. Then ask what other conclusions she would draw.

If you are working with a client and a sponsor, it is wise to present first to your immediate client, then to the client and the project sponsor together. You may find yourself presenting a third time to the sponsor and an executive team. If at all possible, take your immediate client with you. As you introduce each point, present the joint hypotheses first, then ask what conclusions your audience would draw.

Propose Solutions. Propose two or three alternative "solution packages" to your client, together with the pros and cons (costs/benefits, risks/wins) of each. Then invite input, modify as appropriate, and ask the client to choose which solution package to implement. We have had much success with this approach. If you are working with several levels of clients, you may go through this process a number of times, as described above. However, work to ensure that the solution is selected at the highest possible authority level.

For example, a consultant working with a large auto manufacturer developed three possible sets of solutions: a rock-bottom minimal one, a high-end ideal one, and one between the two that was still robust enough to ensure the systemic problem was solved. He then named each set of solutions for well-known cars: a very cheap, low-prestige car; a top quality car; and a mid-range vehicle. The decision-makers were at the department-head level. They did not want to make a choice that associated them with the rock-bottom vehicle, but they did want to minimize their investment, so they chose the mid-range option.

Explore Implementation Issues. For each solution package you present, make implementation options part of your deliberations with the decision-makers. Implementation is integral to the costs/benefits and risks/rewards of each solution. Where you can, use the implementation process as another opportunity to add value.

One of us worked with a software implementation firm that wanted to increase profitability by standardizing the use of its project management tools and methodology. Part of the solution was job simulation training that required new project managers to learn the methodology by using specific tools. Obstacles included many officially blessed "tools" that were not fully functional, and newly hired project managers sent to remote client sites with little guidance. Also, the training organization lacked the staff to check the quality of the learners' work as they completed each task in the simulation. Implementation was structured so each new project manager was assigned to a guide, an experienced project manager. As the learner completed a simulation task, she sent it to the guide for review and feedback. The guides had an answer key for each task. They quickly developed a personal interest in their learners' success and made a large public fuss if a tool or a step in the methodology was found to be faulty.

This ensured that both experienced and new project managers became very skilled at using the tools and official methodology, and that reputable users brought faulty tools or processes to the organization's attention to be fixed. Strong relationships between new and experienced project managers were built, creating a community of practice and a support system that went far beyond the original training objectives to add value.

Implementation can often benefit from an OD rather than a scientific approach. While a scientific approach is fitting for analysis and prescription, this is not always the best way to get people to

change their practices and beliefs. HPT models are not the only useful models available, and we should look to other fields for what they offer (Wittkuhn, 2008). There are also issues raised in the section on Organizational Politics earlier in this chapter that are part of implementation work. You need both a technical and a political plan to succeed.

Additional Organizational Alignment Models and Job Aids

Don Tosti and Stephanie Jackson developed a useful Organizational Alignment Model that clients, performance consultants, and OD consultants find mutually understandable (Tosti & Jackson, 1994). It pairs the strategic side of business (goals, objectives, and activities) with corresponding elements of culture (values, practices, and behaviors) and shows how all must be aligned in order to translate the organization's mission and vision into results. Strategy addresses what needs to be done, and culture addresses how it should be done—or at least how it is done. This model, shown in Figure 4.4, is particularly useful for reviewing and assessing alignment of goals versus activities, and alignment of practices versus goals, strategies and values. Their article explaining the model in detail is on the web at www.vanguardc.com/org_align.html.

FIGURE 4.4. *Organizational Alignment Model.*

GAINING OWNERSHIP OF ANALYSIS, SOLUTION, AND IMPLEMENTATION PLANNING

It is one thing to do a brilliant job of analysis, diagnosis, and prescription and to build a well-thought-out implementation plan. We find it can be a much bigger challenge to get people in our client organizations to accept it and act on it. This is another situation in which we have found it helpful to turn to OD experts who have developed and tested principles and tools for engaging organizational members in change efforts. Two useful principles to remember are that:

■ People don't resist change, they resist being changed

■ People support that which they help create

Here are two resources we have found helpful for engaging people at all levels in a change effort:

Flawless Consulting. Peter Block's classic book provides practical techniques for partnering with your client at every stage of the consulting process, from data gathering and analysis through choosing a solution and planning implementation (Block, 2000). This book is an investment that will pay dividends for as long as you work with organizations. Pay particular attention to the chapter on implementation.

The Grove Consultants International. The Grove, at www.grove.com, offers a set of large, wall-sized templates for leading a group through many organizational assessment and planning activities. Each has a leader's guide explaining how to use it with groups of different sizes and compositions. The templates use a visual metaphor to frame a task, such as assessing the organization's context.

One of us has extensive experience using this visual approach and finds that it is equally successful with clients at any level of an organization. Tape it on a wall in front of the group, simply ask questions, and write their responses to fill in the blanks. When a template is complete, everyone can see all the interacting elements of their organization's context and their inter-relationships. The templates have been broadly tested and applied successfully to many organizational uses.

Especially useful for engaging clients in assessment are the templates titled Context Map and Industry Structure Map, both based on Porter's External Scan. The Five Bold Steps and the Graphic Gameplan templates are wonderful for group problem solving and implementation planning. Executive groups typically respond to the templates with enthusiasm, because they help show the big picture without sacrificing the complexity they must deal with to make good decisions.

Being Persuasive at a Distance

To enroll people in organizational change, performance consultants must craft messages that will hold up when we are not personally there to deliver them. We must capture people's imaginations, then enable them to pass their conviction along to others in the organization (Heath & Heath, 2007).

CONSULTANT'S ROLE IN IMPLEMENTATION

When performance improvement specialists work at the Workplace/Organization Level, our role is considerably different than it is at the Worker/Individual or job level. At the Individual Level,

we are often implementers as well as analysts and problem-solvers, especially if the solution involves job aids, references, or training. At the Process Level, we are usually part of an implementation team.

At the Organization Level, our role is that of a consultant. As consultants, we advise, propose, and recommend. We present solution sets, with the pros and cons of each, and senior management decides what to do. They are answerable for organizational results, and implementing organizational change is their responsibility. We may recommend resources, but the leader decides whether or not to use them. When we identify issues, we ask the sponsor or champion to take them forward for resolution. We do behind-the-scenes work, helping our immediate clients to manage up and ensure that all changes are integrated and that everyone is aligned around the execution of the solution. We ensure that the solutions to be implemented are aligned at all three levels of the organization. The guidelines in *Flawless Consulting* (Block, 2000) are especially helpful to performance consultants working at the Organization Level.

Management Practices for High Performance

Whether your client is trying to implement change or just create and maintain a high level of organizational performance, there are some common management practices that can help or hinder her. Table 4.3 lists several that we have found to be important.

TABLE 4.3. **Management Practices That Help or Hinder Organizational Performance.**

Help Organizational Performance	Hinder Organizational Performance
The strategy is understood and supported by all levels of management	Multiple initiatives without clear priorities
Issues are confronted in meetings and resolved	Failure to de-commission initiatives that are no longer aligned with current strategy and direction
Executives and managers are held accountable for their commitments and performance	Lack of follow-through on strategies and initiatives
Decisions are made in a timely manner and at the appropriate level	Focus only on immediate pressures, not on the long-term health of the organization
Executives and managers exhibit respect and trust for one another, and there is an absence of silo thinking	Narrow focus on own area of responsibility alone: silo thinking

Source: Adapted from Geary Rummler, PAR Workshop: Four Views Analysis Guide (worksheet). Used with permission.

True Tales from the Trenches

To pull together the key elements of performance improvement efforts at the Workplace/Organization Level, we share two true tales and their results.

Horizontal and Vertical Alignment. The revenue accounting group in a large, 130-year-old railroad purchased an automated revenue accounting system to replace their manual process. The critical business issue: the railroad had tens of millions of dollars of uncollected revenue outstanding, much of it over ninety days old. Fragmentation of the manual accounts tracking process allowed overdue bills to float for months. This drove the decision to automate the revenue accounting process.

The railroad hired a small consulting firm to develop training for the new system. The consultants helped their clients see that training alone would not result in successful implementation. The software was built on assumptions about workflow that would require massive changes: workflows, procedures and processes, employees' roles, and the way people and the organization were managed. Because it was a collective bargaining environment, the risk of contention was also high.

The consultants worked collaboratively with members of the client organization to map and re-engineer work flows, change fragmented specialty jobs into customer-focused work teams, and build a team-based organization with completely different work policies and practices. The physical workplace was reconfigured and the new workflow and procedures were simulated and tested, allowing employees and managers to learn their new roles and interactions in advance of the change.

Results: The managers, employees, and the bargaining unit enthusiastically supported the changes. Uncollected revenues more than ninety days old were reduced by 75 percent, and cash flow increased by $40 million U.S.

Horizontal Alignment and Goal Versus Action Misalignment. The U.S. sales division of a large computer hardware-manufacturing firm asked a performance consultant to create a visual map of their business development process. The presenting problem: sales teams didn't understand the business development process. The business issue: inconsistent practices between sales teams were resulting in customer dissatisfaction and a slow sales cycle, affecting both cash flow and cost of sales. The client wanted a clear illustration of the business development process to create consistency in how the process was followed.

As the project unfolded, it became clear that each region had a different process, and even within regions there was little consistency. It also became clear that not only were sales involved, but that business development was a cross-functional process. The consultant and her client established a cross-functional task force to define, refine, and implement a process that all key stakeholders agreed on. The task force identified and eliminated many process steps that didn't contribute to sales, and even identified some irrelevant jobs.

Results: The organization fixed and aligned the sales process and cut the average sales lead time by weeks. Because managers with large numbers of employees had greater prestige in the

organization's culture, the irrelevant jobs were preserved. The job classification system also assigned higher compensation levels and perks to managers with greater numbers of employees. This remained an example of practices being out of alignment with goals and strategies, to the detriment of organizational results.

APPLICATION EXERCISE

Now you try it. Use the guidelines below to select one of three models to map your organization:

If . . .	Then . . .
You do not already have a sense of how the organization fits into the larger system of suppliers, competition, markets, and customers	Create a super-system map, based on the Anatomy of Performance chart, Figure 4.1.
You do not have a clear 360-degree understanding of the business: the thinking behind its marketing, products and services, processes, internal structure, and its financial goals and strategy	Create a map of its business logic using the Business Logic Job Aid and worksheet, Figure 4.3.
You would like a broad general picture of the forces acting on your organization and how it fits into its industry, or you want to try working with graphic tools work before using them with a group	Create a Context Map and Industry Structure Map using supplies from The Grove.

CONCLUSION

The Organization Level is the highest of three levels in an organizational performance system. It is the most challenging for a performance consultant to address, and it is also offers the greatest leverage. This is our best chance to raise our efforts from an episodic approach to a true systemic approach to solving a performance issue. Not many performance consultants are yet asked to help organizations at this level, and our literature is not yet full of cases, tools, and solutions. We have to keep a sharp eye out for opportunities and hone our political skills to pursue them. Our best tools for working at this level are good questions, careful listening, and persistence. Many issues that show up as Worker Level performance problems are actually due to poor alignment of goals and initiatives at the Organization Level. If you can help leaders see what better alignment can do for their organization, you can really start making a difference. In Chapter 6, What We Do, we explore the HPT consulting process.

WHERE TO GO NEXT

To learn about . . .	Go to . . .
Worker/Individual Level	**Chapter 2**
Problem Solving	
Analysis	
Tie to the Business	
Models and Tools	
Work/Process Level	**Chapter 3**
Process	
Critical Process Issues	
Practice	
Maps—Making It Visible	
Implementation: Integrating Performance into the Organization	**Chapter 5**
What Is Implementation	
Episodic Versus Systemic	
Failure Versus Success	
Making It Stick	
Models and Tools	
What We Do	**Chapter 6**
Systematic Approach	
Project Management	
Models and Tools	
Focus Forward: Trends to Watch	**Chapter 7**
Trends That Impact Clients	
Natural Resources	
Technology	
Economics	
Performance Improvement	
Chart Your Course	**Chapter 8**
Worker/Self	
Work/Process	
Workplace/Organization	

AUTHORS' PICKS

Here are some recommended additions to your library and helpful subscriptions.

Library Additions

Becker, B.E., Huselid, M.A., & Ulrich, D. (2001). *The HR scorecard: Linking people, strategy, and performance*. Boston, MA: Harvard Business School Press.

Block, P. (2000). *Flawless consulting* (2nd ed.). San Francisco, CA: Pfeiffer.

Bossidy, L., & Charan, R. (2002). *Execution: The discipline of getting things done*. New York: Random House.

Carleton, R.J., & Lineberry, C.S. (2004). *Achieving post-merger success: A stakeholder's guide to cultural due diligence, assessment, and integration*. San Francisco, CA: Pfeiffer.

Hale, J. (1998). *The performance consultant's fieldbook*. San Francisco, CA: Pfeiffer.

Heath, C., & Heath, D. (2007). *Made to stick: Why some ideas survive and others die*. New York: Random House.

Herbold, R. (2004). *The fiefdom syndrome*. New York: Currency Doubleday.

Reger, S.J.M. (2006). *Can two rights make a wrong? Insights from IBM's tangible culture approach*. Armonk, NY: International Business Machines Corporation.

Rummler, G.A., & Brache, A.P. (1995). *Improving performance* (2nd ed.). San Francisco, CA: Jossey-Bass.

Rummler, G.A. (2004). *Serious performance consulting: According to Rummler*. Silver Spring, MD: International Society for Performance Improvement.

Helpful Subscriptions

The Wall Street Journal

Your local *Business Times* publication

Harvard Business Review

McKinsey Quarterly

CHAPTER

IMPLEMENTATION: WEAVING PERFORMANCE INTO THE ORGANIZATION

The Service Fitness project took shape at a statewide insurance company where the declining performance of three hundred customer care managers in field offices had resulted in a request for additional training. The two performance consultants on the project quickly discovered that the customer care managers were experienced, long-term employees faced with a number of challenges, only one of which required training. The other challenges were:

■ Following obsolete procedures

■ Misunderstanding/misusing internal controls

■ Confusion about work priorities

■ Lack of staff cross training

■ Lack of delegation skills

■ Lack of contingency planning

With the support of their client, the finance manager, the consultants designed and developed a front-end analysis to expand the information they had already gathered. By meeting individually with each key stakeholder, the consultants were able to gather detailed information and build consensus at the same time. When they formally reported their findings, the stakeholders understood the complexity of issues impacting the customer care managers and were open to a multi-layered solution.

The consultants responded by proposing a three-day off-site offered regionally around the state to actively involve all the stakeholders. Core elements of the Service Fitness project were:

- Pre-work to gather data to be used in the off-site

- Alignment among executives on establishing and communicating service-related priorities to the field

- Opening session to gather critical issues from customer care managers in attendance

- Activity-based sessions on identifying and setting priorities and contingency planning

- Delegation skills training

- An open forum on Service Level Agreements with the managers of the supporting processing centers

- Distribution of job aids for the twenty-five most commonly delegated tasks

- Post-program project designed and completed by each customer care manager to improve work in her/his office, presented regionally six weeks later

Service Fitness was a major departure from other programs previously experienced by the customer care managers. Results included:

- Dramatic reduction in the number of customer care managers going out on stress leave

- Results from post-program projects published and distributed to all customer care managers for their use/adaptation

- Twenty-five job aids expanded to include those suggested by customer care managers and the regional processing centers, became an on-going project to standardize operational procedures across the organization that was updated quarterly

- Systematic delegation of lower level responsibilities to junior employees

- Reassignment of leadership in the processing centers to ensure that service level agreements were met and that the concerns expressed by the customer care managers during the Service Fitness program were addressed

WHY THIS CHAPTER?

How many times have you managed, participated in, or observed the implementation of a carefully considered and well-designed performance improvement solution, only to watch it fade away after a short-lived existence? How often have you invested hours of your time and expertise only to see your efforts disappear soon after implementation? Unfortunately, you are not alone. In a July 2008 study of executives worldwide, McKinsey reports that only one-third said that their organizations succeeded in making a change in performance (McKensey, 2008). A 2005 study conducted by VitalSmarts and the Concours Group (Silence Fails, 2006) cites a failure rate of 85 percent in major projects undertaken by organizations. Tellingly, the study also found that 90 percent of employees could identify the large-scale initiatives in their organization that were likely to fail.

Sadly, many finely crafted solutions that really could make a difference to an organization's results suffer from implementations that don't have staying power. It is likely that such initiatives met one or more of these obstacles:

■ Plans were never fully executed

■ Implementation was completed, but the change was not embedded in the organization's culture

■ Nothing was done to ensure that the change had sticking power

IMPLEMENTATION DEFINED

Implementation means to "carry out, accomplish; especially to give practical effect to and ensure of actual fulfillment by concrete measures" (Merriam-Webster, 2003). An implementation embeds a change in behavior, systems, management practices, or relationships and includes activities before, during, and after to weave the solution into the fabric of the organization.

In practical terms, a successful implementation is as carefully designed as the change it puts in place. The implementation design includes:

■ Expected results clearly linked to the business

■ Extensive communication exchanges with stakeholder representatives

■ Active inclusion of affected employees

■ Visible support of senior management

■ Identification of all affected processes

■ Careful consideration of the organization's cultural norms

When these elements are present, we can say that we have successfully built a performance improvement solution, implemented it, and integrated it into the organization.

Implementing a New Law

Some years ago, a new U.S. law, the Family Leave Act, required employers to provide time off for employees for a variety of critical family needs such as caring for a child or parent during illness. The human resources department asked us to help simplify, and make accessible to the organization's managers, procedures for applying the law within their departments (Addison & Haig, 1999).

The materials we received were lengthy. However, the spirit of the law was favorable to employees and was likely to be helpful to many. Using our knowledge of the organization's culture, the extensive administrative responsibilities of the managers, and the complexities of current employee leave policies and procedures we focused on reducing the size of the documents and making them easy to use. We identified the most common reasons for employees requiring leave, removed repetitive information, and combined the new law's requirements with established company procedures to put all leave-related information in one document. This ensured that the new law's requirements would become part of standard management practices.

Working with HR, representative managers, and the legal department, we reduced thirty-six pages to a six-page job aid using a format familiar to both HR and the managers. For scalability, the implementation plan (see Table 5.1) included both an explanatory cover letter to introduce the new law and job aid as well as a brief presentation suitable for a managers or Human Resources meeting.

TABLE 5.1. **What Gets Implemented.**

Workplace	Work	Worker
Reorganizations	Job Redesign	Performance Criteria
Plans	Automation	Feedback Systems
Initiatives	Technology	Development Programs
Regulations	Teams	Certifications
Policies	Standards	
Mergers	Re-Engineered Processes	
Change in Facilities		

Source: ©2008 International Society for Performance Improvement. Used with permission.

From Episodic to Systemic Implementation

Generally, there are two kinds of implementation: episodic and systemic. An episodic implementation plan is designed against symptoms rather than drivers/causes. Such implementations are unmoored. That is, they have goals, but these are not tethered to those of the larger organization and so cannot be sustained. Weary employees recognize this as an example of "flavor of the month" to which they respond casually, knowing that whatever-it-is will soon be history.

A systemic implementation, however, addresses root causes/drivers, is long-lasting, and is engineered to stick. This implementation is designed horizontally in the organization, and moves across functions to involve all affected workers, processes, and related aspects of organizational culture.

To produce sustained implementation of a performance improvement solution, we suggest you focus on the RSVP+ principles of performance improvement:

■ Achieve sustained results by emphasizing the ends (results) rather than the means (how you get there)

■ Take a systems view to ensure you include all functional areas in the organization that will be touched in any way by the solution—look sideways

■ Consider the value you will add to the business with a sustained implementation of the solution—what is important to the organization to achieve and maintain, and how you can support that

■ Partner with stakeholders such as clients, champions, functional representatives, and others who will be impacted by your implementation to ensure sustained adoption of the initiative

■ Remember the + and implement only solutions that fit the organizational norms and that the culture will embrace

Implementation Failure Versus Implementation Success

A failed implementation is easy to recognize according to the VitalSmarts/Concors Group study cited earlier (Silence Fails, 2006). It may be characterized by:

1. *Fact-Free Planning.* A project is set up with deadlines or resource limits that are disconnected from reality.

2. *AWOL Sponsors.* A sponsor fails to provide leadership, political power, time, or energy to help a project through to completion.

3. *Skirting.* People work around the priority-setting process.

4. *Project Chicken.* Team leaders and members don't say there are problems with a project but wait for someone else to speak up.

5. *Team Failures.* Team members are unwilling or unable to support the project and feed into dysfunctional behavior.

Do these look familiar? As performance improvement consultants, we are uniquely positioned to help craft carefully thought-out, sticky implementation plans. We can ensure that implementations include the RSVP+ principles and link to the goals driving the organization. We can help implement in ways that match how the organization operates. As Harold Stolovitch reminds us:

"Our professional duties require us to lay aside preconceived notions, especially in unfamiliar settings. Our job is to observe, gather credible information and test-retest our perceptions before we draw conclusions or make performance improvement decisions"

Source: Stolovitch, Harold. (2008). *Talent Management, 4*(5), 10.

Some reasons for the failure of implementation are shown in Table 5.2.

TABLE 5.2. **Reasons for Implementation Failure and Derailment.**

Category	Reason
Investment	No compelling vision No sense of urgency Divided attention Leaders not accountable Insufficient infrastructure Too few quick wins Not understanding the time and resources needed for people to learn
Innovation	Failure to learn Get stuck in the present Heavy reliance on annual strategic and performance reviews
Communication	Insufficient communication
Governance	Staff takes the lead (HR, IT) A disconnect between vision and action Slow and ineffective decision making Murky roles, responsibilities, accountabilities, and process measures Ineffective delegation of execution to others
Involvement	Lack of critical mass Weak employee engagement Insufficient attention to customer needs
Culture	Insufficient change in the culture Change seen as an organizational process The environment shifts Weak monitoring of processes
Alignment	Misalignment of rewards No outside perspectives Inability to work laterally across functions and departments

Source: ©2008 International Society for Performance Improvement. Used with permission.

Both the design and plan for the implementation should be systemic—inclusive of all involved functions on all three levels of the organization. Specify a planned "shelf life" for the initiative and select checkpoints for review and revision to keep pace with other organizational priorities. To increase the odds of success, Judith Hale offers Ten Steps to Successful Implementation.

Ten Steps to Successful Implementation

1. Agree on the goals, scope, and measures

2. Set the baseline

3. Assess feasibility

4. Develop an implementation game plan to actualize the goal

5. Identify leading and lagging indicators

6. Put an oversight structure in place

7. Sustain attention

8. Measure rate of adoption and report

9. Shift ownership

10. Reward adoption

©Judith Hale 2008. Used with permission.

HOW TO MAKE AN IMPLEMENTATION STICK

An implementation that sticks is one that weaves the performance improvement solution(s) into the fabric of the organization so that it essentially becomes part of the organizational culture. Once the "weaving" is in place, it is difficult to dislodge because ripping it out would also dislodge other critical cultural components. An example is the implementation of the Family Leave Act discussed earlier, where procedures for the new law were combined with those in place for other types of employee leave situations. For eight more examples of successful HPT implementations see Addison and Haig (1999).

A reason why implementations are not successful is because organizations often emphasize managing change, rather than implementing it with lasting impact. Much effort is spent communicating about the change, instead of ensuring that everyone affected is actively engaged with the change.

One approach to sustainable implementation that we like is Lance Dublin's I³ Change Implementation Model (Haig & Addison, 2008), a scalable aid that can help you weave performance improvement implementations into the organization so that they stick. The model (shown in Figure 5.1) has three stages:

- **Inform**—explains the change/initiative/program using a consumer marketing approach with branding, positioning, tagline creation, and activities to raise awareness that a change is coming

- **Involve**—actively engages all stakeholders hands-on in the implementation

- **Integrate**—ensures that the implementation results become part of the organization's culture

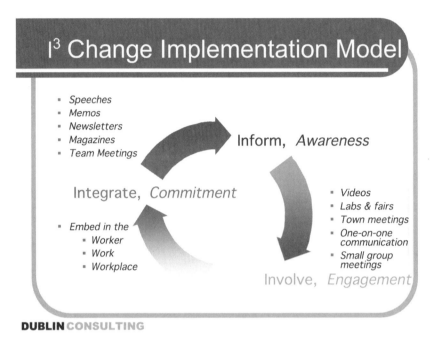

DUBLIN CONSULTING

FIGURE 5.1. *I³ Change Implementation Model.*
Source: ©Lance Dublin. Used with permission.

CONCLUSION

For the implementation of a performance improvement solution to achieve its intended results, it must have staying power. Since the majority of such implementations are not successful, it is critical that practitioners be able to weave performance into the organizations where we work. We can:

- Ensure that the three components of implementation are present

- Help our organizations move from episodic to systemic change

- Apply the RSVP+ principles of performance improvement to every implementation

- Follow the Ten Steps to Successful Implementation

- Draw from the suggestions of established practitioners provided

- Access the I³ Change Implementation model to guide our planning

WHERE TO GO NEXT

To Learn About . . .	Go to . . .
Worker/Individual Level	**Chapter 2**
Problem Solving	
Analysis	
Tie to the Business	
Useful Models and Tools	
Work/Process Level	**Chapter 3**
Process	
Critical Process Issues	
Practice	
Maps—Making It Visible	
Workplace/Organization Level	**Chapter 4**
Mapping the Organization	
Critical Business Issues	
Problem Solving: Alignment	
Proposing Solutions	
Implementation	
Related Management Practices	
Models and Tools	
What We Do	**Chapter 6**
Systematic Approach	
Project Management	
Models and Tools	
Focus Forward: Trends to Watch	**Chapter 7**
Trends That Impact Clients	
Natural Resources	
Technology	
Economics	
Performance Improvement	
Chart Your Course	**Chapter 8**
Worker/Self	
Work/Process	
Workplace/Organization	

AUTHORS' PICKS

Here are some recommended additions to your library:

Library Additions

Bossidy, L., & Charam, R. (2002). *Execution: The discipline of getting things done.* New York: Crown Business.

Heath, C., & Heath, D. (2007). *Made to stick: Why some ideas survive and others die.* New York: Random House.

Langdon, D., Whiteside, K., & McKenna, M. (Eds.) (1999). *Interventions resource guide: 50 performance improvement tools.* San Francisco, CA: Pfeiffer.

Stolovitch, H., & Keeps, E. (Eds.). (1999). *Handbook of human performance technology* (2nd ed.). San Francisco, CA: Jossey-Bass/Pfeiffer.

CHAPTER

6

WHAT WE DO

One of the joys of working in the field of performance improvement is the variety of organizations, projects, and opportunities practitioners have to make a measurable difference for their clients. Human performance technology (HPT) is a broad discipline that welcomes generalists and specialists at all levels of skill and experience. In the course of a performance improvement project, regardless of its size or complexity, the consultants on the project team are usually expected to take on a variety of roles and responsibilities. While this aspect of the work can be challenging, it also encourages the acquisition of new skills and potentially provides new learning opportunities with every project—another plus for our field of work.

SYSTEMATIC APPROACH

At its core, as described in Chapter 1, The Performance Technology Landscape, is the Systematic Approach we use to improve performance—what we do. As we explore the elements of the approach, we will highlight the particular project management actions typically associated with each element. Most of us in the performance improvement field frequently wear the project management hat, and the Systematic Approach lends itself to demonstrating what we do as project managers. Table 6.1 shows the parallels between the Systematic Approach and Project Management Processes.

We prefer to keep our project management responsibilities as simple as possible. Most of our work is not as complicated as building a highway around a major city, so we have not yet seen the need for project management software. We build our own tables, open item lists, and other tracking tools, updating them as the project advances. This works well. That said, a number of our colleagues regularly use and swear by project management software, such as Microsoft Office Project™.

TABLE 6.1. The Systematic Approach and Project Management.

Systematic Approach	Project Management Processes
Identify Issue	Initiating
Define Result	Planning
Conduct Performance Analysis	Executing
Take Action	Executing
	Controlling
Plan the Solution	Closing
Implement the Solution	Closing
Evaluate	Applies to All Processes*

*Evaluation is done for each phase in the Systematic Approach

KEY TERMS

In Chapter 1, The Performance Technology Landscape, we introduce three key terms. Let us revisit them here to help us understand the Systematic Approach:

System

Just as the human body is a system composed of various parts, in HPT we view every organization as a complete system comprised of elements like functions, divisions, departments, and the like. These elements are what we call Systems.

Systems

Similar to the human body with its circulatory system and skeletal system, we further divide the elements of an organization into sub-systems such as work teams, functions like HR, sales and marketing, information technology, and others.

Systemic

An herbicide or chemical that works by spreading through all the tissues of a plant, rather than just staying on the leaves, is systemic. That is, it affects all parts of the plant. This describes the HPT view of how organizations operate: everything in the system/organization affects everything else,

and every change made to one component of the system has an impact on all its parts. If HR, for example, implements a new performance management system, every employee in every part of the organization will be affected.

COMPONENTS OF THE SYSTEMATIC APPROACH

Skilled performance improvement professionals will likely cite a specific model that they developed or use to guide them through a Systematic Approach to a particular performance improvement opportunity. Established experts like Harold Stolovitch, Don Tosti, Geary Rummler, Judith Hale, and Margo Murray have their individual views of what constitutes a Systematic Approach to performance improvement. However, all the models are reproducible and have these elements in common: diagnosis, prescription, and evaluation. A representative example is the Performance Consulting Systems Approach model shown in Table 6.2 (ISPI, 2004). The approach shown is not linear, even though it appears so in this model.

TABLE 6.2. **Performance Consulting Systems Approach.**

	Step	Description of Step	Result
Ongoing relationship with clients and participating in the business as a partner	1. Identify and Review Issue (Problem/ Opportunity) with Client	☐ Proactively identify, or reactively review, client's perspective on a potential issue and identify how addressing the issue would increase stakeholder value ☐ Agree on evidence the client will accept that the goal has been met	☐ The real organizational issue clarified ☐ Client determines whether or not it is worthwhile to pursue
	2. Assess Performance Against Expected Results	☐ Assess performance against expected results (through existing or new measures and/or ongoing monitors)	☐ The performance gap identified and described in measurable terms
	3. Identify Requirements for Success	☐ Identify relevant factors of successful performance at appropriate system levels (barriers/requirements)	☐ Barriers to success described ☐ Required components for successfully achieving expect results described

(Continued)

TABLE 6.2. *(Continued)*

	Step	Description of Step	Result
Ongoing relationship with clients and participating in the business as a partner	4. Recommend Solutions	☐ Narrow down to most relevant factors of successful performance ☐ Identify alternative solutions applying human performance technology criteria ☐ Evaluate alternative solutions/approaches to address the most relevant factors (assumptions, cost, benefits, risks) ☐ Communicate recommendations from client's perspective (from Step 1)	☐ One or more solutions selected by client
	5. Design/Implement Approved Solutions	☐ Co-develop implementation plan with client ☐ Design/develop solutions to support approved plan ☐ Support plan implementation	☐ Implementation plan developed ☐ Solutions to close gap designed and developed ☐ Plan implemented
	6. Monitor Performance Against Expected Results	☐ Assess performance against expected results ☐ Recommend next steps	☐ Performance assessed against results ☐ Next steps recommended

Source: ©2004 International Society for Performance Improvement. Used with permission.

For discussion purposes, consider that the Systematic Approach is composed of the six core elements presented in Table 6.2, plus one more—Evaluation. Let's use them to explore the steps in the process and the types of results a skilled performance consultant is likely to generate. Remember that what follows in the Systematic Approach in Table 6.3 is presented step-by-step. However, in reality, the nature of organizations, people, and information cause overlapping steps, backtracking, and skipping ahead. Ultimately, all the steps in the Systematic Approach will be covered, and the results described here will be achieved. Note that the applicable role/responsibility for each step in the process is described to emphasize the agility required to successfully bring a performance improvement project from conception to full integration in the organization.

TABLE 6.3. Systematic Approach.

Phase	Description	Typical Roles
Issue	**Establish need** ■ Identify issues, needs, and opportunities ■ Identify benefits to the organization of meeting the needs or taking advantage of the opportunities	**Consultant** Gather information from managers and other experts; help clarify expected benefits
Define Result	**Define outcomes** ■ Identify the desired result—whether a tangible outcome or a desired state ■ Specify requirements for the outcome—what organizational constraints must be met	**Consultant, Analyst** Work with managers and experts to define expected results that can be measured, and help them identify outcome requirements
Conduct Performance Analysis	**Determine what impacts the issue** ■ Conduct performance analysis to identify key influences on results	**Analyst** Gather data using a performance systems model; identify factors that impact the issue
What Actions	**Determine what to do** ■ Examine alternative interventions/ approaches (cost/benefits) ■ Finalize recommendations (business case)	**Analyst, Consultant** Identify potential interventions; evaluate interventions against requirements, costs, and benefits; present recommendations
How	**Plan the intervention** ■ Design/develop methods for implementing the intervention ■ Design/develop plan for integrating the intervention into the organization (change methodology)	**Project Manager, Consultant** Work with design and development specialists to create a solution, ensure that it meets needs/requirements, and specify evaluation methods

(Continued)

TABLE 6.3. *(Continued)*

Phase	Description	Typical Roles
Do	**Implement the intervention** ▪ Conduct a pilot ▪ Modify plans as needed and deploy intervention throughout the organization/group	**Project Manager, Implementer** Work with implementation specialists to provide support, monitor progress, and modify plans as needed
Evaluate	**Evaluate results** ▪ Conduct Formative Evaluation (lessons learned) ▪ Conduct Summative Evaluation (return on investment)	**Analyst, Consultant** Ensure measurement of process and outcomes, analyze data, report results, recommend change as needed

Source: ©2004 International Society for Performance Improvement. Used with permission.

Identify Issue

Most performance improvement opportunities are identified because someone in management specifies a need, problem, or opportunity and looks for a solution. For the issue to have credence, the manager must be able to articulate how addressing it will benefit the organization. Frequently, this is described as the familiar "business case," which many organizations require be documented before any resources are allocated.

Usually, the issue is broader and/or deeper than initially presented, and it falls to the performance consultant to investigate thoroughly to clarify all its parts. Managers, customers, and other stakeholders can help expand the initial business case and elucidate the benefits they anticipate from resolution of the issue. Critical elements of a business case are shown in Table 6.4. These generally include:

▪ Benefits of the initiative described in terms of the current and desired states, the resulting gap, and the impact of closing that gap as reflected in revenue, costs, and other affected elements in section A

▪ Cost of the initiative to both the provider and recipient broken down by the steps in the Systematic Approach listed in section B

▪ Projections of potential returns from the success of the initiative, from section C

▪ Decisions and next steps from section D

TABLE 6.4. Business Case.

A. Benefits of Requested Initiative

	Critical Job Issue	Critical Process Issue	Critical Business Issue
Gap ■ **"Is" Result** ■ **"Should" Result**			
Impact of Closing Gap ■ **Revenue** ■ **Cost** ■ **Other**			

B. Cost of Requested Initiative

	Costs to Provider Organization	Costs to Recipient Organization
A. Analysis		
B. Design/Development		
C. Production		
D. Delivery		
E. Initiative Maintenance/Support		
■ Year One		
■ Year Two		
■ Year Three		

(Continued)

TABLE 6.4. *(Continued)*

	Costs to Provider Organization	Costs to Recipient Organization
F. Evaluation		
G. Management Support		
▪ Year One		
▪ Year Two		
▪ Year Three		

C. Potential Return on This Initiative

	Year One	Year Two	Year Three
Benefit			
Cost			
Net			
Cumulative Net			

D. Decision and Next Steps

____ A. Proceed with the proposed initiative, as requested	1. Prepare Project Plan to develop proposed initiative
____ B. Conduct brief analysis to clarify need and appropriate action	1. Prepare Project Plan for analysis
____ C. Not a good use of resources at this time	1. Put proposed initiative on "hold" 2. Requestor strengthen business case
____ D. Rethink proposed initiative and business case	1. Requestor re-examine apparent need
____ E. Other	

Source: ©2004 Geary Rummler and the Performance Design Lab. Used with permission.

The performance improvement specialist works in a consulting role to produce these outcomes: a clear issue statement, or description of the current state, supported by a strong business case and clearly articulated expected benefits from successful resolution of the issue. The initiating manager or designee becomes the client for the project.

Project Management for Issue Identification—Initiating. With the business case developed, we're ready to get management's sign-off and begin. In project management terms, this is often referred to as "initiating." This is where the requisite information is provided to the client and the project is authorized (Greer, 1996, p. 13). The consultant is likely to be involved in budget discussions, negotiations, presentations, and other preliminary communications to launch the project.

It is a good practice, at this stage, to clarify who the ultimate client is—that is the person who signs off on the completed project and who funds the work—and what your expected contact with the client will be during the project. It helps to be clear about the value of the project to the client and to the organization. This is the time to identify the executive sponsor and let this person know that the project has been launched. In Chapter 4, The Workplace: Organization Level, you'll find a complete discussion about executive sponsors or champions. Ask your client to name the various subject matter experts (SMEs) who will review the project deliverables.

Define Result

This is a further refinement of issue identification. It calls for the performance improvement specialist to partner with managers and appropriate stakeholders to define the desired result in terms of a tangible outcome or a desired state. The work done here includes specifying requirements for the anticipated outcome and identifying the organizational requirements that must be met. Ultimately, the expected results must be measurable.

With organizations facing continued fiscal constraints in our volatile economy, leaders are carefully examining every proposal that comes before them to ensure that, if adopted, it will result in measurable gains in such areas as revenue, profits, market share, community impact, or brand recognition. A carefully constructed business case, using the elements called out earlier, will point to the significant metrics to track.

The results are identified outcome requirements, or the standards the solution must meet for the project to go forward. A useful guide to establishing criteria for each result is the familiar S.M.A.R.T. goals model (*SMART Goals*, 2008). A S.M.A.R.T. goal is:

- *Specific*. Rather than a general goal such as, "Reduce employee turnover," try "Use the five company employee retention strategies to reduce turnover."

- *Measurable*. Set criteria to measure progress toward the goal. Describe how much, how many, and how you will know you have accomplished your goal. "Use the five company employee retention strategies to reduce turnover by 10 percent by January 31."

- *Attainable*. A successful goal is one that is within reach. If it is a very ambitious goal such as, "Use the five company employee retention strategies to reduce employee turnover by 50 percent," breaking it down into annual or even quarterly goals will make it easier to visualize success and increase the chances of achieving it.

■ *Realistic.* A goal is probably realistic if those behind it believe that it can be accomplished. Has a similar goal been reached in the past? What conditions must exist to accomplish this goal? "Use the five company employee retention strategies to reduce employee turnover by 10 percent each year for the next five years, and ensure full management participation."

■ *Timely.* A goal should be time boxed so that it has an anchor and creates a sense of urgency. Set a date and include it in the goal statement. "Follow the five company employee retention strategies to reduce employee turnover by 10 percent each year for the next three years, and ensure full participation by requiring end-of-month updates from all managers as part of their regular progress reports."

Project Management for Defining Results—Planning. As we've seen, the most effective way to begin improving performance is to start at the end. Sometimes we get lucky, and the client can clearly and accurately specify the results of a successful project. From there, it is a brief excursion to identifying the measurements that will show the degree of the project's success. When we know the destination, we can plan the journey.

Here, we are in the Planning stage of project management where we develop the project plan, from analysis forward as far as we can anticipate, and identify the resources we need. These include SMEs, managers, exemplary performers, performance improvement designers and developers, and perhaps others who will join the project team as we move forward. It is a good idea to source the documents that will help with the analysis at this stage and to identify sites for observation and data gathering. Identify the deliverables that result from each step in the plan.

Some organizations follow a standardized project management process and have planning tools and templates available. To create your own, there are a number of helpful publications suited to the types of projects performance improvement professionals manage. We like Michael Greer's *The Project Manager's Partner* (Greer, 1996) and Timm Esque's *No Surprises Project Management* (Esque, 1999). The latter lends itself to projects at the Workplace/Organization level.

Conduct Performance Analysis

This step looks deceptively simple in the Systematic Approach table (Table 6.3). In reality, it is usually the most layered activity in the Performance Improvement Process. Performance Analysis involves:

■ Planning the scope of a diagnostic investigation of the performance improvement problem or opportunity

■ Selecting data gathering methods, identifying stakeholders to interview, and scheduling observations to see first-hand the work, workers, and workplace where the performance improvement issue is present

■ Determining when, how, and to whom to report Analysis findings and recommendations

In the analyst role, the performance improvement specialist looks specifically at the gap between the current and desired states of the performance issue and generates probable causes or drivers. Performance issues can become apparent at any of the organizational levels—in the processes, with particular workers or work groups, or across the organization. During Analysis, it is important to

determine whether the drivers are resident at a higher level so that the origins of the issue are identified and addressed.

The wise performance consultant also relies on a performance systems model, such as the Total Performance System (Brethower, 1982) to ensure that all areas of the organization that are or could be touched by the performance issue are identified. We introduce the Total Performance System (TPS) in Chapter 2, The Worker: Individual/Team Level. We like this model because it is scalable and suits performance improvement work at any of the three organizational levels. Figure 6.1 is another rendition of the TPS.

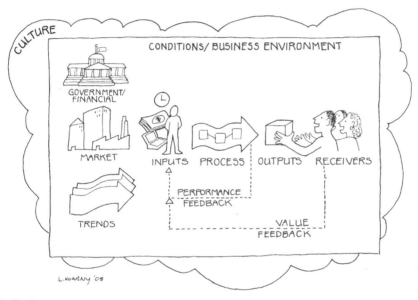

FIGURE 6.1. *Total Performance System.*

Expect Surprises. Performance Analysis is rather like home repair—it is rarely as simple as we assume when we begin removing the first layer of wallpaper. It helps to be prepared for surprises such as the SME who is suddenly unavailable or uncovering evidence of issues more complicated than anticipated. In such situations, remember that when the findings start to repeat, your data gathering is probably complete.

One of us worked with a large international technology company that makes products for the pharmaceutical industry. A new product was to be introduced and the sales manager wanted to know what information the salespeople needed to sell it and how best to ready them for the launch. Two of the promised analysis resources were to be sales goals and sales production information from each geographical location. These never materialized. After poking and prodding unsuccessfully, the consultant negotiated for additional analysis funding, increased the scope of her interviews, and gathered the missing information anecdotally. It was sufficiently accurate to complete the analysis.

Frequently, an analysis turns up information already known to the client, but the performance consultant provides the added value of confirming it and performs the important tasks of organizing it for the client.

Making Recommendations. When an analysis results in a long list of recommendations, be nice to your client, and prioritize them, placing those with the most impact first. You will probably find that the first two or three have an obvious priority order, that one or two belong at the very end of the list, and that the remaining recommendations carry equal weight and can appear anywhere in-between.

For the technology project described above, the consultant made eleven recommendations. The client agreed that the first three of these were critical and then chose a few more from the balance of the list to be acted upon.

Sometimes, a consultant contracts and launches a performance improvement project only to learn that certain areas are off limits. This can have quite an impact on the project, particularly if the analysis data points to the forbidden area as a possible driver/cause of the performance issues.

Two consultants were working with a large public health organization to help them with their new hire orientation program. Early in the analysis phase, the senior management team told the consultants they could not consider the structure of the organization as an influence on employee recruitment or retention, nor could they make recommendations about how the business should be run. Since it appeared likely that the design of the business did contribute to many of the internal issues the organization faced, the consultants had to work around the business design when making their recommendations.

Presenting Analysis Data. Performance Analysis results in a detailed description of the performance issue and the drivers or causes responsible. Quite possibly the analysis will raise several related concerns, and it may identify a broader opportunity for improvement than originally described. Chapter 4, The Workplace: Organization Level, presents guidance for organizing analysis data and presenting it to senior leaders. It is a good practice to apply the same rigor to all presentations of analysis data to clients at any level of the organization. Here are some reporting techniques for presenting analysis data to clients at any organizational level, both in written reports and in visual-driven presentations. Choose one or more that suit your project:

- Place an executive summary at the beginning of your findings report and lead with information that confirms what the client asked for or assumed you would discover

- Use the elements of the project's business case to organize and present the findings

- Follow the format of the investigative model you used in your analysis to give continuity to the report

- Present the findings in the body of the report with a few representative statements from interviewees to give key concerns more impact and ground them in reality

- Attach the logistical information in an appendix—things like the number of people interviewed, observations made, locations visited, specific questions asked

Project Management for Conducting Performance Analysis—Executing. In project management terms, we are now in the Executing phase. A detailed analysis blueprint with action items, dates, resources, sites, and specific activities laid out will help immeasurably and allow you to accurately track multiple streams of information. As circumstances change—the key subject-matter expert you spent weeks trying to schedule has suddenly gone on leave—your detailed plan will help you find other information sources.

Consider organizing your analysis blueprint with one eye on how you will present your findings to your client. The more orderly your analysis plan documents, the easier it is to pull together the results and draw conclusions that flow logically from the information you have compiled. Take a close look at the models and tools you are using in your analysis to see if their layout can guide your analysis report.

Actions to Take

This is where the performance consultant determines what can be done to resolve the performance issue(s). In many such situations, the possible solution may be composed of several actions that are best addressed in sequence. A colleague refers to this as the "basket of solutions" (In conversation with Lane, 2008). In other cases, there are clear-cut choices the client must make about what to do. Certainly there are time and budget considerations that may eliminate some possible solutions. And critically, there are cultural norms that must be factored in so that the chosen solution will be implemented and accepted.

Consider Cultural Norms. Sometimes, significant cultural norms don't make themselves known until solution development is well underway. One of us did a project with a public relations department in a large organization. The manager wanted a way to quickly orient his new hires, mostly transfers from within the company, to their new roles in his department and in their communities so that they could be productive right away. The consultant designed a do-it-yourself orientation program that the new hire drove with the help of a mentor and the local administrative assistant. There were written guides for each role. All the materials were housed online for easy retrieval. A few weeks after implementation, the client phoned to say that the administrative assistants had requested a class on the program because they were uncomfortable without one. "We always have a class," they said, stating a company norm. If your performance improvement solution breaches one of these, you must either address it or find a different solution.

Partnering with the client at this stage to examine all possible solutions provides a reality check that can save time and effort. The more invested your client is in the Actions to Take, the better the chances of a successful implementation and resolution of the issue(s).

This step results in recommended solutions that meet requirements, budget, and the expected benefits identified in the business case at the beginning of this process. At the conclusion, the client selects the solutions(s) and determines how to proceed.

Project Management for Actions to Take—Executing and Controlling. Since the project is still in process during this stage of the Systematic Approach, we continue in the Execution phase of project management. During Execution, consultants typically encounter challenges as they move the project forward. This is called Controlling because aspects of the project can shift or cause difficulties during

Execution and require plan changes. For example, your analysis may have uncovered some issues to investigate further. These may affect several project plan components and can ultimately change the schedule and the project's scope. In such circumstances, it is helpful to consult checklists or other tools to help clarify what has occurred and how you might proceed (Greer, 1996, pp. 119–121).

How—Plan the Solution

With the solution selected, the work of designing and developing it begins. Considerations include:

- Establishing a project team to execute the solution

- Identifying how the solution's success will be measured and evaluated

- Ensuring that the solution meets the needs and requirements specified at project inception

- Designing communications, materials, and related solution components

- Selecting a change management methodology for successful integration into the organization

- Deciding, with the client, who will own the completed project and be responsible for its continued maintenance

This step results in a complete package of plans and materials approved by the client that meet the original project requirements for performance improvement and that specify how the project will be evaluated.

Project Management for Planning the Solution—Closing. The performance consultant may be responsible for analysis only, so the project ends with solution recommendations. Or the project might end at this phase in the Systematic Approach with the delivery of all completed materials. In either case, the comparable project management phase is Closing and calls for the formal completion and shutting down of the project, with team members returning to their regular responsibilities and the project materials stored and maintained as planned at project inception. Closing includes the client's formal sign-off on the project (Greer, 1996, pp. 125–127).

Do—Implement the Solution

There are a number of critical aspects to implementation that differentiate an initiative that is implemented but never fully integrated into the organization, from one that is carefully orchestrated to become part of its fiber. As project manager and implementer, the performance improvement professional has much to do, including:

- Planning the complete implementation

- Ensuring all involved segments of the organization are supportive and invested in the success of the project

- Determining how the implementation and its aftermath will be evaluated and monitored and by whom

- Piloting the implementation and making adjustments to the overall plan

- Setting specific goals for the ongoing life of the project

Working with implementation specialists and client representatives, the performance consultant establishes support mechanisms and monitoring processes for the project, and provides for any needed modifications to plans and materials.

Implementation is covered in greater detail in Chapter 6, Implementation: Weaving Performance into the Organization.

Project Management for Implementation—Closing. The performance improvement professional is uniquely qualified to design and support a project implementation that fully integrates it into the organization. We encourage you to do all you can to continue with projects through this critical step in the Systematic Approach rather than turning them back to your client. From a project management perspective, at the conclusion of implementation, you execute the Closing activities described earlier in Project Management for Planning the Solution.

Evaluate

In many HPT models, the evaluation step appears at the end. In the Systematic Approach, it is in this position because something has to be last. In reality, the seasoned performance consultant ensures that a well-designed and managed performance improvement project has evaluation built into every step. This will allow adjustments and modifications as needs arise, saving time and expense throughout the life of the project.

In the roles of analyst and consultant, the performance improvement professional plans to evaluate effectiveness and value at each step throughout the project.

Formative Evaluation. Performance Consultants conduct formative evaluations during solution design, development, and implementation to improve the effectiveness of the solution. This type of evaluation:

- Provides information about the solution while it is still under development and can be revised before additional investments are made

- Is performed on prototype material and solutions

- Checks progress

- Is conducted to determine the adoption or continuance of a solution and leads to a "go/no go" decision

The consultant uses formative evaluation techniques to identify lessons learned so that appropriate adjustments can be made for the balance of the project, providing performance feedback to the project team and the project's client.

Summative Evaluation. Performance consultants perform summative evaluation after implementation, to determine whether the solution closed the gap and whether or not it was worth the investment. Summative evaluation provides feedback on the value of the project to the finance group, the customer, and other stakeholders.

Today, savvy organizations look at the return on investment (ROI) for performance improvement project implementations. Much as been written and studied about how best to track and calculate the ROI for training programs (Stolovitch & Maurice, 1998) and other performance improvement solutions.

In organizations where the balanced scorecard is used to evaluate results throughout the organization, it is quite possible to use it to evaluate a project after implementation because the balanced scorecard provides a direct link to the business results (Silber, 2008). As with all forms of evaluation, be sure the balanced scorecard elements are identified early in the project so they are in place when needed.

As a performance consultant, you want to find out which metrics your organization is tracking and which ones they particularly care about, such as those related to yearly targets and goals. Whether you are establishing the worth of taking on a project during the analysis phase or measuring the results at the end of implementation, you want to focus on metrics that the organization is currently trying to improve.

The four balanced scorecard categories identified by Kaplan and Norton (1996) are

- Financial perspective
 - Return-on-capital-employed
- Customer perspective
 - Customer Loyalty
 - On-time delivery
- Internal – Business – Process Perspective
 - Process quality
 - Process cycle-time
- Learning and Growth Perspective
 - Employee skills

We have found it useful to adapt these categories to meet clients' individual requirements. Table 6.5 lists common metrics organizations use to track each of these categories. Consider the list as a menu from which to choose meaningful measures.

TABLE 6.5. **Balanced Scorecard Metrics Menu.**

The Balanced Scorecard: Financial Metrics

 Organization Level (Workplace)

 - Profit/Profit Margin
 - Earnings Per Share/ Price to Earnings Ratio
 - Profitability
 - Return on Investment (Assets/Sales/Equity)
 - Margin (Operating/Net/Gross)

- Cash Flow
- Costs
 - Direct/Indirect
 - Variable/Fixed
- Solvency
 - Current and Debt to Equity Ratios
 - Asset Turnover

Process Level (Work)

- Cost of Goods Sold (COGS)
- Salary and General Administration (SG&A)

Performer Level (Worker)

- Sales Per Salesperson
- $ Collected/Recovered
- Hire/Replacement Costs

The Balanced Scorecard: Customer Metrics

Organization Level (Workplace)

- Size of Market Segment
- Share of Market
- New Customers
- Current Customer Renewal
- Complaints
- Net Profit/Customer

Process Level (Work)

- Cycle Time
- Order Fulfillment
- Returns
- Complaints

Performer Level (Worker)

- Complaints
- Customer Approach/Avoidance
- Customer Requests for Specific Performer

(Continued)

TABLE 6.5. *(Continued)*

The Balanced Scorecard: Product/Service/Image Metrics

Organization Level (Workplace)

- Company Image
 - Knowledgeable/Innovative
 - Proactive /Helpful
 - Speedy Service
- Relationship Between Company and Customer
 - Convenient /Responsive
 - Guarantee /After-Sale Service
- Product/Service
 - Novelty
 - Functionality
 - Returns

Process Level (Work)

- Product/Service
 - Quality/Timeliness/Volume
 - Safety (Number Accidents, Number Days Without Injuries)
 - Order Fulfillment (Percent Complete, Cycle Time, Number Defective)
- Image
 - Convenient/Responsive
 - Knowledgeable (Number of Questions Answered, Number of Inquiries Handled Without Escalation)

Performer Level (Worker)

- Number of Complaints
- Number of Greetings/Welcomes Given, Number of Customers Approached, Number of Thanks Given
- Helpful (Number of Complaints Resolved, Problems Solved, etc.)

The Balanced Scorecard: Process Metrics

Organization Level (Workplace)

- Cost of Goods Sold (COGS)
- New Products/Services to Market
- Number of Process Improvements (Reduce COGS, Cycle Time, Just in Time)

Process Level (Work)

- Research and Development, Production, Distribution, Post-Sales, Infrastructure
 - Quality
 - Cycle Time
 - Process Time
 - Value-Added Activities
 - Coordination
 - Cost
- Work In Process (WIP)
- Inventory
- Rework/Waste

Performer Level (Worker)

- Value Chain Core Competencies Identified and Tracked
- Productivity
 - Customers/Accounts Per Employee
 - Items Produced/Resolved Per Hour
 - Rework/Waste

The Balanced Scorecard: Internal Metrics

Organization Level (Workplace)

- Salary and General Administration (SG&A)
- Information Technology: Cost of Ownership
- Turnover/Retention
- Regulatory Compliance

Process Level (Work)

- IT: Mean Time Between Failures (MTBF)
- Recruitment and Hiring: Cycle Time, Costs
- Human Resources Processes Exist
 - Job Design
 - Career Development
 - Knowledge Management
 - Organizational Learning
- Performance Goals Exist, Are Communicated, Feedback Mechanisms Exist

(Continued)

TABLE 6.5. *(Continued)*

- Auditing Processes Exist, Are Used
- All Major Internal Processes Designed for Effectiveness and Mapped (IT, Procurement, Finance and Accounting, Strategic Planning, etc.)

Performer Level (Worker)

- Percentage of Performance Plans/Appraisals Completed
- Goals Set, Communicated, Followed Up On
- Feedback Given/Received on Regular Basis
- Job Satisfaction

Source: ©2007 International Society for Performance Improvement. Used with permission.

Guidelines for Success

Using project management skills and performance improvement tools and techniques to successfully navigate through the Systematic Approach is part art and part science. We share with you two lists of what to do and what not to do:

Ten Guidelines for Success as a Performance Consultant

1. Provide relevant information—know what you are talking about

2. Have the courage to speak up—believe that what you can contribute is of value

3. Make people feel comfortable—communicate with warmth and care

4. Trust what you hear (and verify it)—seek corroborating evidence

5. Learn the politics—make your client look good

6. Ask the difficult questions—make people stop to consider new information

7. Establish your credentials—ensure your clients know you are well-regarded outside their group or organization

8. Establish a presence—what is your signature and what are you known for?

9. Remain impartial and objective—form opinions without choosing sides

10. Stay focused—your goal is to improve performance; being liked is secondary

 Adapted from Hale (1998), *The Performance Consultant's Fieldbook*

Ten Mistakes to Avoid as a Performance Consultant

1. Forgetting to ask the question, "If this is the solution, then what is the problem?"

2. Assuming that a client who is difficult to reach and communicate with before the project begins will be more available and agreeable once the project is launched

3. Ignoring assumptions listed in your project proposal when you discover that they are not valid

4. Failing to inform your client as soon as an assigned resource becomes a problem

5. Neglecting to make your client look good

6. Pushing products on your client; instead, partner to solve problems or leverage opportunities

7. Beginning a project without a planned and orchestrated kick-off meeting, even if it is on the telephone

8. Taking on a project without including an analysis

9. Running off at the end of a project; be sure to debrief with your client and project team

10. Ignoring hidden agendas and politics

 Adapted from performance consultants' suggestions compiled by Miki Lane, 2000

CONCLUSION

The Systematic Approach is an end-to-end process with twists and turns and a range of critical roles that can be taken on by one or more practitioners. It consists of six core elements with corresponding project management phases, as shown in Table 6.6.

TABLE 6.6. **The Systematic Approach and Project Management.**

Systematic Approach	Project Management Processes
Identify Issue	Initiating
Define Result	Planning
Conduct Performance Analysis	Executing
Take Action	Executing
	Controlling
Plan the Solution	Closing
Implement the Solution	Closing
Evaluate	Applies to all Processes*

*Evaluation is done for each phase in the Systematic Approach

Sample tools and resources for each element of the Systematic Approach can guide both the novice and the veteran performance consultant to a successful project conclusion. If planned, managed, and monitored with skill, the resulting project is performance improvement that produces the promised results and becomes an integral part of the organization.

What would you like to explore next? Use the following table to decide.

WHERE TO GO NEXT

To Learn About . . .	Go to . . .
Worker/Individual Level	**Chapter 2**
Problem Solving	
Analysis	
Tie to the Business	
Models and Tools	
Work/Process Level	**Chapter 3**
Process	
Critical Process Issues	
Practice	
Maps—Making It Visible	
Workplace/Organization Level	**Chapter 4**
Mapping the Organization	
Critical Business Issues	
Problem Solving: Alignment	
Proposing Solutions	
Implementation	
Related Management Practices	
Models and Tools	
Implementation: Integrating Performance into the Organization	**Chapter 5**
What Is Implementation	
Episodic Versus Systemic	
Failure Versus Success	
Making It Stick	
Models and Tools	
Focus Forward/Trends to Watch	**Chapter 7**
Trends That Impact Clients	
Natural Resources	
Technology	
Economics	
Performance Improvement	
Chart Your Course	**Chapter 8**
Worker/Self	
Work/Process	
Workplace/Organization	

AUTHORS' PICKS

Below are some recommended additions to your library.

Library Additions

Block, P. (2000). *Flawless consulting: A guide to getting your expertise used* (2nd ed.). San Francisco, CA: Pfeiffer.

Brown, M.G. (2004). *Get it, set it, move it, prove it: Sixty ways to get real results in your organization.* New York: Productivity Press.

Brown, M.G. (2006). *Keeping score: Using the right metrics to drive world class performance.* New York: Productivity Press.

Brown, M.G. (2007). *Beyond the balanced scorecard: Improving business intelligence with analysis.* New York: Productivity Press.

Chevalier, R. (2007). *A manager's guide to improving workplace performance.* New York: AMACOM.

Clark, R.E., & Estes, F. (2002). *Turning research into results: A guide to selecting the right performance solutions.* Atlanta, GA: CEP Press.

Daniels, A.C., & Daniels, J.E. (2006). *Performance management: Changing behavior that drives organizational effectiveness* (4th ed.). Atlanta, GA: Performance Management Publications.

Esque, T.J. (2001). *Making an impact: Building a top-performing organization from the bottom up.* Atlanta, GA: CEP Press.

Esque, T J., & Patterson, P.A. (1998). (Eds.). *Getting results: Case studies in performance improvement.* Amherst, MA and Silver Spring, MD: HRD Press and International Society for Performance Improvement.

Greer, M. (1996). *The project manager's partner: A step-by-step guide to project management.* Amherst, MA. HRD Press.

Guerra-López, I. J. (2008). *Performance evaluation: Proven approaches for improving programs and organizational performance.* San Francisco, CA: Pfeiffer.

Hale, J. (1998). *The performance consultant's fieldbook.* San Francisco, CA: Pfeiffer.

Hale, J, (2003) *Performance-based management: What every manager should do to get results.* San Francisco, CA: Pfeiffer.

Kaplan, R.S., & Norton, D.P. (1996). *The balanced scorecard: Translating strategy into action.* Boston, MA: Harvard Business School Press.

Kaufman, R. (2006). *Change, choices, and consequences: A guide to mega thinking and planning.* Amherst, MA: HRD Press.

Mourier, P., & Smith, M. (2001). *Conquering organizational change: How to succeed where most companies fail.* Atlanta, GA: CEP Press.

Robinson, D.G., & Robinson, J.C. (2005). *Strategic business partners: Aligning people strategies with business goals.* San Francisco, CA: Berrett-Koehler.

Robinson, D.G., & Robinson, J.C. (2008). *Performance consulting: A practical guide for HR and learning professionals* (2nd ed.). San Francisco, CA: Berrett-Koehler.

Rossett, A., & Schafer, L, (2006). *Job aids and performance support: Moving from knowledge in the classroom to knowledge everywhere.* San Francisco, CA: Pfeiffer.

Rummler, G.A. (2004). *Serious performance consulting: According to Rummler.* Silver Spring, MD: International Society for Performance Improvement.

Sanders, E.S., & Thiagarajan, S. (2001). *Performance intervention maps: 36 strategies for solving your organization's problems.* Alexandria, VA: American Society for Training and Development.

Sugrue, B., & Fuller, J. (1999). *Performance interventions: Selecting, implementing, and evaluating the results.* Alexandria, VA: American Society for Training and Development.

Van Tiem, D., Moseley, J., & Dessinge, J.C. (2001). *Performance improvement interventions: Enhancing people, processes, and organizations through performance technology.* San Francisco, CA: Pfeiffer.

CHAPTER

FOCUS FORWARD:
TRENDS TO WATCH

One of the most innovative leaders in management and performance improvement is our colleague, Clare Carey. Known for her skill in bringing together disparate teams of workers and aligning them toward common goals, we thought it fitting to use her driving mantra, Focus Forward (Figure 7.1), to train our eyes on the trends impacting business, industry, academia, government, and the non-profit sectors where we work.

FIGURE 7.1. *Focus Forward.*

WHY TRENDS MATTER

The business press and the daily news present the varying views of enterprise executives, business analysts, futurists, and other thought leaders on current trends that affect the global workplace. We have selected some of these trends for discussion because part of what performance specialists bring to their clients is a broad perspective on changes in the world and in commerce as they relate to each client organization. Because performance consultants seek to add value when we work, and because we base our work on organizational goals and desired results, we will look at these selected trends through the lens of performance improvement to reflect the challenges our clients face. Some of these challenges may surprise you.

For example, did you know that employers throughout South Africa are coming together to try to resolve the AIDS crisis in that country? Two of us were in South Africa not long ago and learned that employers there realize that, unless the disease is addressed and managed, there will be no workforce to fuel their enterprises.

Another example: by 2013, China is projected to be the country with the largest number of English-speaking people (China . . ., 2007). How will this development affect our organizations and our worldview?

We will use RSVP+, the four principles of performance technology introduced in Chapter 1, The Performance Technology Landscape, to help us map current trends to performance improvement efforts for our clients, as follows:

R—Focus on Results: Use our knowledge of the business to help clients link their performance improvement initiatives to business needs and goals and initiate such projects by specifying what the end result is to be.

S—Take a System Viewpoint: Consider all aspects of the organization's performance system when we analyze a situation, including competing pressures, resource constraints, near and long-term anticipated changes, as well as its cultural norms.

V—Add Value: Produce results that make a difference to our clients, that speak to what is important to them, both in how we do the work and in the solutions we recommend or develop.

P—Establish Partnerships: Work with clients, representative experts, and other performance improvement professionals to share skills, knowledge, creativity, and successes to produce the intended results.

+ —Remain Solution-Neutral: The + in RSVP+ reminds us that as ethical performance consultants we stay focused on the client's needs and remain solution-neutral, recommending what is best for the client's situation regardless of the solution we might prefer or of our personal expertise.

EXPANDING THE PERFORMANCE TECHNOLOGY LANDSCAPE

The foundation for this book is the Performance Technology Landscape presented in Chapter 1. While the Landscape covers the organizations where people work in some detail, it also includes society as part of the work environment (Kaufman, 2006). It is this perspective that we take as we

consider several trends we believe will continue to influence individuals and organizations around the world for the foreseeable future.

The chosen trends can be grouped a number of ways. For ease of explanation, we've chosen four categories with the caveat that there are interrelationships among these trends. We will discuss some of the connections and leave others to you to explore. The categories:

■ Natural Resources

■ Technology

■ Economics

■ Performance Improvement

Natural Resources

For as long as most of us can recall, there has been an environmental movement. Organizations of concerned people have coalesced around saving natural resources such as the forests, rivers, and numerous endangered species. They have raised awareness for their causes while educating the world about our planet and the damage we humans have done in the name of civilization. We would like to focus on these inter-related natural resources trends:

■ Climate Change

■ Water Supply

■ Oil Supply

■ Going Green

Climate Change. Regardless of one's personal views on why world climates are changing, most people probably have personal experiences related to unusual weather. Weather is defined as, "The state of the atmosphere with respect to heat or cold; wetness or dryness, calm or storm, clearness or cloudiness" (Webster's, 2003). Weather begets climate, which is "The average course or condition of the weather at a place, usually over a period of years as exhibited by temperature, wind velocity, and precipitation" (Webster's, 2003).

We've all seen the news: melting polar icecaps, rising water levels in the oceans, communities relocating to higher land in Alaska and in the tropics, and wildlife displaced. And many of us have experienced unusual storm activity with torrential rains, rising waters, flooding, or tornadoes in places where they normally don't occur. Research tells us that we can expect increasingly violent storms and their resulting devastation to wreak havoc along the world's coastlines (Climate Change Impacts Stronger Storms, 2008).

Likewise, as climates change, the world will experience more floods and drought. Such changes cause immense disruption to human life and to commerce, as we can see. Food supplies, costs, and distribution are affected causing hardship to many. Businesses in affected areas lose workers, supplies, operating capacity, and even their markets.

The effects of climate change are much broader than we can discuss here. Our question to you: How is climate change affecting the organizations where you work, and how can performance improvement models, tools, and processes help to plan and mitigate climate change outcomes?

Water Supply. Have you experienced a drought where you live? Have you rationed your water either voluntarily or in response to a mandatory requirement? Did it raise your awareness of how critical water is for life? Did you begin to imagine how it must be to live in a desert? Water supply, water purity, and water planning are all issues of utmost importance to every living thing on this planet.

As we write this, we are at the beginning of summer in California. After a comparatively dry winter, our well-known fire season has begun early with almost two thousand dry lightening fires started spontaneously around the state. The fire services that unite to fight wildfires are out in force while the resources they need, such as water tankers, are in short supply. At the same time, portions of the mid-western United States are under water with major rivers flooding their banks and destroying the homes and businesses of countless communities.

Water management agencies create their policies based on typical weather patterns observed over decades, constructing dams and reservoirs accordingly. Now that weather patterns are drastically changing, it is more difficult to plan for adequate water supplies and reserves (Martin, 2007). As water becomes less available, people everywhere will be faced with extraordinary survival challenges. Economies could collapse and governments forced to determine equitable ways to distribute precious water while avoiding water wars.

It is likely, by all accounts, that water scarcity will be a fact of life. Some countries are responding proactively. One of us was recently in the Arab Emirates, where he observed a concerted effort to build desalinization plants to produce potable water. As oil supplies diminish (see Oil Supply later in this chapter), these forward-thinking countries are looking for ways to change their economies and to become suppliers of water is just one possible change.

What are the implications for the industries where you work? What do your clients and their leadership say about the future and water supplies? How can you become a part of the conversation?

Oil Supply. At this writing, the oil crisis is front and center as fuel prices climb hourly and the effects flow to every corner of our lives. It appears that the days of relatively inexpensive fuel are over and that everyone will have to make significant changes as a result. All organizations rely on petroleum, if not in the manufacturing of their products, then certainly for the transportation of their workers, the heating of their facilities, and the movement of materials and supplies to and from their locations. Organizations are challenged to keep up with rising fuel costs, even as the costs of all fuel-related goods and services continue to increase.

When costs go up, organizations must find ways to cover them, typically by instituting controls on expenditures. Some companies look for alternatives such as other types of fuels, investing in different transportation options, officing employees in their homes, or reducing travel by increasing electronic communications, holding virtual meetings, and the like. Others pass the increase directly to the customer, as with airlines raising fares, adding fuel surcharges to ticket prices, and cutting back on the number of flights they offer.

Major organizational initiatives that address oil-related issues require analysis, communication, change management, evaluation—in short, they need performance improvement experts to participate in studies, recommendations, solution design and development, and evaluation to carry out the strategies of organizational leaders.

With the world's dwindling oil supply, new energy technologies are in development. There will be performance improvement issues associated with these new developments. How can we prepare to address them?

Going Green. Do you recycle? Does your local waste management company provide special bins for collecting paper, glass, and recyclable plastics? Do they designate certain days during the year to collect items for re-use, to gather hazardous household materials such as paint products, or to collect electronic items such as computers and telephones to be stripped and re-purposed? How about your workplace?

Some companies are making a statement about their world citizenship by taking an active role in recycling. Apple Computer established a take-back recycling program in 2001. To date, they have recycled 90 percent, by weight, of all the electronic equipment they have collected (*Apple and the Environment*, 2008).

As awareness about the quantities of products and materials we consume that are essentially indestructible grows, we see a great disparity from country to country and community to community, for ways to manage what goes in the trash pile. The UK, for example, is experiencing a garbage crisis as landfills reach capacity. There are significant fines for excessive trash disposal and local authorities are strictly enforcing regulations to get Britons to recycle (Lyall, 2008).

But what about the structures where we live and work? Do you work in a green building or have one or more in your community? As the availability of eco-friendly construction materials grows, government buildings, other public structures, private enterprises, and residences are increasingly seeking out such materials to build sustainable buildings. While initially more costly, green building materials very rapidly earn back their expense in reduced heating, cooling, electrical, and water consumption costs. Green buildings create healthier living and working environments because toxic substances are not used in eco-friendly paints, carpeting, and other furnishing materials.

In the United States and in other countries, buildings that are renovated or built from scratch can earn LEED® certification from the U.S. Green Building Council by following guidelines and meeting specific standards. One of us worked with the Council on a user training program and was privileged to see and learn, first-hand, how the standards are established, evaluated, and monitored (U.S. Green Building Council, 2008). A major selling point for building green, among others, is reduced employee absenteeism, because a healthier building has healthier employees.

How do ecological and environmental concerns manifest themselves in your client organizations? What is their view of how stewardship of our planet and they, as an enterprise, impact the community? Do they offer their employees carbon offsets? What environmental regulations apply to the industries where you work, and how do they impact performance?

Technology

It is difficult to discuss technological trends because anything we observe will change before we finish writing about it. That said, we want to look at three phenomena that will continue to challenge and influence the workplace and deserve our attention:

- The Role of the Internet
- The Convergence of Technologies
- The $100 Computer

The Role of the Internet. The Internet has changed the way much of business is conducted in the world. It has bridged time zones, crossed borders, given voice to millions of people, and multiplied the amount of information human beings can access with a computer, some software, and a modem. At the same time, the Internet is a hotbed of illegal activities, scams—how many deposed Nigerian royals have courted your personal funds?—terrorist activities, pornography, and more private details than you may want to know about celebrities. It is also the repository of quantities of misinformation and just plain junk. The wise Internet surfer is selective in the medical sites she visits for information, on the financial institutions she banks with online, and in safeguarding her personal information as she surfs into new territory.

Businesses, universities, governments, professional associations, and individuals have flocked to the portals of the ether to advertise and sell products and services, acquire and share information, download movies and music, find soul mates, and view fabulous photographs from around the world. You can buy postage stamps online, balance your checking account, send wedding pictures to Aunt Flossie, and get the best price on a new vacuum cleaner on eBay. The Internet is "becoming our map and our clock, our printing press and our typewriter, our calculator and our telephone, and our radio and TV" (Carr, 2008, p. 60).

Most organizations have the capacity to put information online internally so that their employees can access human resources forms, company publications, price lists, and other business tools. We have developed new work strategies and new habits because of the Internet.

How is this vital part of our work and personal lives put to use by your clients? How can you leverage that in your quest to help improve performance?

The Convergence of Technologies. Whatever did we do before we had Google? Imagine being a young person today and not knowing a world without it: we don't "look it up" anymore, we "Google it." The websites we visit know more about us than our own mothers, and that information is used to display customized product information tailored to our interests and buying habits.

Google, besides being an online super power, is a critical research resource that is convenient and easy to use. And Google has lofty goals and the resources to reach them. They would like to supplement our brains with electronics. According to Larry Page, one of Google's founders, Google is "really trying to build artificial intelligence and do it on a large scale" (Carr, 2008, p. 62).

And what about the iPod and the iPhone? Currently, the world is watching the convergence of technologies and related services, a consolidation of resources into single locations. Apple and other technology leaders continue to explore ways to bring a variety of media to a single piece of electronics: the cell phone. Apple has its computers, iTunes and other software, the iPod, Apple TV, and the iPhone. And the iPhone, and its competitors, may well be where all the technology comes together.

What do these products and events mean to performance improvement? Employers are hiring an entire generation of young workers who grew up with technology, who are accustomed to ingesting quantities of media during all their waking moments. They send text messages on their iPhones while listening to music and simultaneously Googling for information or reading the latest CNN

newsfeed. Their work habits are different and they bring expectations into the workplace that many older supervisors are not yet equipped to address (Gayeski, 2008). This is the workforce for whom we help our clients build and manage performance systems, and it behooves us to learn how they interact with technologies.

The implications for us, as professionals using new technologies, are also significant. We are responsible for keeping up with changes, even those we don't use directly, to help our clients make wise decisions about deploying initiatives and using technological tools to their advantage. We aren't required to be technology experts, but we can add value by being conversant in the latest developments that impact our clients.

The $100 Computer. In addition to computers in the pockets of many of us, a number of philanthropists, universities, and other organizations are committed to bringing technology to underserved populations around the world and are finding innovative ways to do so. The $100 computer, as it is typically described, has several identifying characteristics, regardless of its origins. It is smaller and lighter than a PC or a MacBook. It has Linux open-source software, smaller capacity, basic applications, and few extras. MIT announced it was building a computer that would sell for a bit more than $100; an extremely successful Indian entrepreneur is building them from older monitors for sale for $100 in India; and the One Laptop Per Child (OLPC) project, one of the early bright lights on the path to inexpensive computing, has since faltered and will probably not reach its goal of mass producing and distributing such a machine.

What is the significance of the trend toward a $100 computer? It can open the world to underserved children and adults, bringing them into the mainstream, enhancing their knowledge and employability, and connecting them instantaneously to information they never conceived of. It means that the flat world Thomas Friedman writes of will get flatter (Friedman, 2005). As this, and projects like it unfold, what are the implications for the organizations we serve? How will their business models, supply chains, and communications evolve to include this huge new market? And how will we help them make the necessary changes?

Economics

Significant global trends that impact everyone at every level in their work and personal lives include:

- Innovation in the Workplace
- Rise of India and China

Innovation in the Workplace. Innovation is in the spotlight again as economies in most countries react to the oil crisis, and businesses consider how best to navigate the choppy waters of commerce for the foreseeable future. When economic times are tough, what steps do your client organizations take? Do they cut funds for their research and development departments? Cancel plans to update computer systems and equipment? Cut back on sending employees to seminars? Decimate the training department?

Or are your clients saying that, although times are tough, now is a critical time to innovate? The companies that comprise the 2008 *BusinessWeek*-Boston Consulting Group's ranking of the World's

Most Innovative Companies share this view (McGregor, 2008). They value their creative employees in all economic climates. They know times change, and they work to develop a range of products and services that will see them through the rough periods.

An organization's approach to innovation says a great deal about its culture and values. As the world struggles to learn about and understand the effects of what our society has built over the years, we need creative thinkers who can generate intelligent responses to problems we have never encountered before. A knowledge of how your clients are likely to plan for change, and the extent to which they foster innovation, can provide you with valuable clues about how best to raise a concern or suggest something new.

Rise of India and China

India. If you have problems getting online or a question about your cell phone, does your technical support come from a call center in India? Does the food court at your local shopping mall have a purveyor of Indian curry next to the yoghurt stand? There may be lovely Indian saris displayed at a nearby clothing boutique. Your co-workers might be recent arrivals from one of the technical colleges in India or be of Indian decent. If you live and work where a sizable number of Indians have come to stay, you have probably observed or heard something of India's current boom.

Besides the controversial practice of U.S. businesses outsourcing work to India, within India there is a tremendous entrepreneurial drive that is fueling the economy at unprecedented rates (Zakaria, 2006). Numbers of Indians attend the world's finest universities and many of them return to their home country to add their expertise to the growth of business. Every year, HB1 visas bring skilled Indian workers, particularly in information technology, to join U.S. companies. Recently, one of us worked with a large clothing manufacturer, spending time at their data center where most of the programming and systems maintenance are done. The consultant walked entire floors at the center and heard predominantly Urdu and Hindi rather than English.

What connections do your client organizations have with India? Have functions been outsourced there and local jobs lost? How are these arrangements likely to grow or change over the next several years? What effects will the changes have on goals, strategies for reaching them, and on the workers who carry them out? What competition from India or from Indian-owned organizations is or will be faced by your clients? How will your clients regard the business climate when India is a dominant world power? Your ability to bring an informed global perspective to your performance improvement activities adds value for your clients.

China. With China's rapidly changing political environment, increasing democratization, tremendous capacity to manufacture almost anything, not to mention individual industrialists who are accumulating vast wealth, this is a major Asian power on a rapid rise. Despite disastrous floods in 2008, the Olympic Summer Games in Beijing and the economic gains reported have focused world interest more closely on China. What is occurring in China is changing Asia, and will change the world (Zakaria, 2006). China has been among the world's fastest-growing countries since the early 1990s and provides an array of manufactured products to other countries, particularly the United States.

China also has considerable financial investment abroad. At the close of 2006, it totaled US $73.33 billion worldwide (China's Total Foreign…, 2007). Chinese companies manufacture millions of computer components and other electronic products purchased by the organizations in which we

work to improve performance. These same organizations may have offices, plants, or representatives in China, may invest in businesses there, or may, in the case of academic institutions, actively recruit Chinese students.

If most predictions come to pass, China will be playing a greater part in world economics in the future and will likely touch many of our client organizations in some way. What are your clients saying about China?

Performance Improvement

And so we come back to our Landscape for a closer look at trends in our own field of performance improvement. We will investigate three trends here:

- Organizational Culture and Strategy

- Spotting Opportunities

- Performance Improvement: The Integrator

Organizational Culture and Strategy. Edgar Schein defines culture as

"A basic set of assumptions that defines for us what we pay attention to, what things mean, and how to react emotionally to what is going on, and what actions to take in various kinds of situations."

Source: Schein, Edgar (1992, p. 22). Reprinted with permission from John Wiley & Sons.

Culture is the DNA of an organization. For people in the business of performance improvement, it is critical to understand the culture within the organizations where we work so that we can get things done in ways that will move our projects forward and show our accomplishments in a favorable light. Perhaps culture is more of an organizational fact of life than a trend. What matters is that we give it due consideration, always.

Culture has always driven how things are done in organizations and will continue to do so. It is intrinsically tied to daily activities such as: how information is communicated, who hears first, why certain people are copied on emails, who to go to for the inside story, what it takes to be promoted, how reports are formatted and who gets to see them, and a million other details of daily transactions.

Culture dictates organizational politics and the hierarchies, protocols, acceptable behaviors, and appropriate terminology that are part of political practice in any organization. See Chapter 4, The Workplace: Organization Level, for more on organizational politics. Meanwhile, assess the culture in the organizations where you work by going online to take one of a number of culture quizzes. This one is courtesy of Inc.Com: www.connecttwo.com/article_mirrors/corporate_culture.html. What does it show you about your client organizations?

Employees who work for a particular entity for a while usually grasp the culture and work within the "rules." For outside consultants who are in and out of many organizations, all the cultural aspects may not be readily apparent. This is where your client and other internal contacts become critical to your success and the success of the performance improvement efforts you are working on. These folks are essentially your interpreters, able to explain the reasons for behaviors you witness and

actions you must take. Partner with them to learn the ways of their organization. Remember, "Culture rules," so regardless of personal feelings, respect it and play by its conventions. As Peter Drucker said, "Tomorrow's business challenges are less technical than they are cultural. Culture must be managed just like any other business phenomenon" (Drucker, 2001).

Spotting Opportunities. V is for Value, as in RSVP+, the core principles of performance improvement, repeated at the start of this chapter. Here, as we look ahead, is a trend we have participated in and one we would like to encourage: identifying additional performance improvement opportunities and pursuing them. We're talking about a situation where a performance improvement practitioner is working on a project and discovers an opportunity to address a completely different issue, either instead of, or in addition to the initial project, thus adding value for the client. Two clues to such opportunities are:

- A variance in the system
- A critical business issue that is in need of attention

Variance in the System. We have all seen these: the store that has greater revenues than others in the territory, the factory shift with lower production than its counterparts, the manager whose team consistently receives the highest ratings on customer service. When you spot one of these variances, go take a look for yourself. As we state in Chapter 3, The Work: Process/Practice Level, and in Chapter 6, What We Do, observation is your indispensable tool for analyzing performance in organizations and adding value for your client.

One of us worked with a team of telephone sales representatives who took calls from prospective customers asking for quotes on car insurance. The sales representatives' job was to provide the quote and sell the caller a policy. The consultant observed that one of the sales representatives had more than double the sales of the next highest producer, so she sat with the representative to find out why.

The sales rep:

- Set her own sales goal ten times higher than the one set for her team: $1 million by year-end

- Had her own business cards printed and went out on weekends to give her cards to the salespeople at local car dealerships, asking that they have their customers call and she'd take care of them (In California, you must have proof of insurance to drive a new car away from a dealership.)

- Mapped out the shortest route in the office for the tasks she had to perform so she saved time dropping off paperwork, faxing, and posting her sales

- Disconnected her headphones only after she stood up and connected them again before sitting down, giving her more on-phone time than her teammates

- Used phone wait and hold time to send her card and a copy of the quote to everyone she talked to, even if they said no to the policy offer, and included cards for other driving-age people in each household

As a new salesperson, this rep exceeded her $1 million goal in just eight months. The consultant identified the opportunity to replicate this exemplary performer's goal setting and work procedures with all the sales representatives in the group.

Critical Business Issue. Significant business problems afflicting a group you are working with can also be clues to opportunities for performance improvement, even if they are not directly related to the project you are working on.

One of us was developing training for the regional managers of a heavy equipment manufacturing company. The regional offices sold and installed the equipment on client sites, sold maintenance contracts, and dispatched technicians to routinely service or fix the installed equipment. Some issues discussed while the consultant was there were escalating labor costs and loss of market share to competitors who charged less for their services.

In discussing operations, the consultant learned that technicians with basic skills could handle routine service calls, but most of the regional managers hired only top experienced technicians. Clients often asked the technician on a routine call to deal with additional mechanical problems they hadn't called in, or problems with related equipment. Experienced technicians could handle such requests on the same call, and customers liked that, especially since they were charged only for additional materials, not for a second call.

The consultant also learned that technicians turned off their pagers when they got on-site, and left them off until they finished the job and the required paperwork. Sometimes they also got some coffee before they turned the pagers back on. This meant dispatchers couldn't reach them for emergency calls, so more technicians had to be on staff to meet service level agreements with customers.

This presented a great opportunity to speed response times, reduce labor costs, and regain market share by changing hiring, pager, and dispatching processes.

Design Performance. Some performance improvement opportunities may take the form of designing performance rather than repairing performance that is broken. Some clarifying examples:

- One of us was asked to help an executive revamp a management position to match the company's new emphasis on customer service. In addition to identifying the components of the updated position, this consultant designed a complete performance system around the position and those that reported to it.

- Some colleagues who specialize in branding went into a large non-profit to align the many publications with appropriate branding. They discovered that the publications were produced in a range of sizes, most of which required custom-sized envelopes to mail them to requestors. Our colleagues ended up re-sizing the publications to fit standard envelopes, saving the organization a reported $10 million in production and postage costs each year.

- Another colleague responded to continual complaints from the company's field offices about the quantities of inter-office mail received daily and the impossibility of handling it all. To investigate, she had a mailbag identical to the ones sent to the field offices delivered to her daily for a month. She became well acquainted with the contents and discovered numbers of reports that were routinely mailed out for which there was no known purpose. The project turned into a

massive effort to eliminate unnecessary and duplicate reports and other publications going to the field. This too, saved millions.

Finding Opportunities. So how does the savvy performance consultant spot these value-add opportunities? One way is to be a good detective. Be inquisitive whenever you begin a project, visit locations, or observe operations that are new to you. Ask why equipment is placed where you see it; ask who consults the manuals and where those people sit; question why the storeroom has strange, dust-covered objects in it that you can't identify; inquire about the placement of file cabinets, all alone at the end of a hallway. There is no substitute for courteous inquiry as you sniff around the Performance Landscape. The people who see the same scene every day no longer notice what you, as the new pair of eyes, will see.

Here is one more example. Do you remember whitewall tires—the ones with a white stripe around the middle? If you own a classic automobile, or you grew up in the time of "white sidewalls," you may know that new whitewalls always came wrapped in paper. This was so the white stripe would stay clean and protected during shipping and the black of other tires wouldn't rub off on the white.

Eventually, whitewalls went out of fashion, all-black tires became the norm, and they were wrapped in paper for shipping. At some point, a new employee saw this and asked why. Investigation turned up the history related here and the realization that the paper was no longer needed. Imagine the paper and labor costs saved! There is tremendous value in a fresh pair of eyes in an organization.

Be a good detective, keep your eyes and ears open, ask questions, and uncover opportunities to improve performance while adding extra value for your clients.

Performance Improvement: The Integrator. In Chapter 1, The Performance Technology Landscape, we introduce the concept of performance improvement as the single discipline best positioned to integrate performance improvement across organizations using the methods, tools, and techniques that form the basis for our work. We view the role of performance improvement professionals as integrators as a trend that will continue in the coming years.

Our technology takes an integrative approach driven by a systematic process that can incorporate performance improvement at all three levels of the organization. Look what we can do (Addison, 2007):

- Link business, education, and government goals and strategies to results

- Identify opportunities and analyze performance problems

- Design systems that enable people to do their best work

- Support individuals, teams, organizations, and the greater society in increasing the value of the results they produce

- Promote a variety of methodologies and applications all driven by the same principles of RSVP+

As we write this, a lively electronic interchange of ideas is in progress among a large group of our colleagues discussing the future of the performance improvement profession. The concept of performance technology as an integrative discipline has been proposed as a way to think about, write, present, and market our skills to prospective clients.

There are a number of approaches to improving performance familiar to us and to our clients, from Six Sigma, to lean manufacturing, to organization development, and others. Six Sigma's focus, for example, is on outputs, and lean manufacturing's is on process, rather than on people and practices. That said, despite different models, tools, and terminologies, these methodologies have more in common than they have differences. With our focus on sustained results, the power of performance technology is evident. "The integration of the worker, work, and workplace is the key to improved organizational performance" (Addison, 2007).

CONCLUSION

Performance improvement professionals who keep up with current events and follow the global trends that affect their client organizations position themselves to add value to their client engagements and important perspectives to their work. The ability to discuss the business of our client organizations in the context of the trends offered here, and there are many others we might have selected, adds to practitioners' credibility and to the richness of the skills they bring to their clients.

We have focused on significant trends in the arenas of Natural Resources, Technology, Economics, and Performance Improvement, as seen through the filter of RSVP+. We recognize that there are other trends we have not noted here that certainly merit attention, such as the rise of the Gulf States in the Middle East and the emerging prominence of countries in Africa. We encourage you to keep up with these and other trends that are important to you and your clients.

As of this writing, the economic stability of much of the world is in question. There will be many changes, but what will they be? Keep your eyes open, and start building your own hypothesis. What is happening? What's likely to happen next? And what are the opportunities to improve performance in this rapidly shifting landscape?

WHERE TO GO NEXT

To Learn About . . .	Go to . . .
Worker/Individual Level	**Chapter 2**
Problem Solving	
Analysis	
Tie to the Business	
Models and Tools	
Work/Process Level	**Chapter 3**
Process	
Critical Process Issues	
Practice	
Maps—Making It Visible	
Workplace/Organization Level	**Chapter 4**
Mapping the Organization	
Critical Business Issues	
Problem Solving: Alignment	
Proposing Solutions	
Implementation	
Related Management Practices	
Models and Tools	
Implementation: Integrating Performance into the Organization	**Chapter 5**
What Is Implementation	
Episodic Versus Systemic	
Failure Versus Success	
Making It Stick	
Models and Tools	
What We Do	**Chapter 6**
Systematic Approach	
Project Management	
Models and Tools	
Chart Your Course	**Chapter 8**
Worker/Self	
Work/Process	
Workplace/Organization	

AUTHORS' PICKS

Here are some recommended additions to your library and useful subscriptions.

Library Additions

Diamond, J. (2005). *Guns, germs, and steel: The fates of human societies.* New York: W.W. Norton.

Drucker, P.F. (2001). *The essential Drucker.* New York: HarperCollins.

Friedman, T.L. (2005). *The world is flat: A brief history of the twenty-first century.* New York: Farrar, Straus and Giroux.

Gladwell, M. (2000). *The tipping point: How little things can make a big difference.* New York: Little, Brown.

Johansen, B. (2007). *Get there early: Sensing the future to compete in the present.* San Francisco, CA: Berrett-Koehler.

Norman, D.A. (2002). *The design of everyday things.* New York: Basic Books.

Pershing, J.A. (Ed.). (2006). *Handbook of human performance technology* (3rd ed.). San Francisco, CA: Pfeiffer.

Peters, T. (2003). *Re-imagine! Business excellence in a disruptive age.* London: Dorling Kindersely.

Pfeffer, J., & Sutton, R.I. (2006). *Hard facts dangerous half-truths and total nonsense: Profiting from evidence-based management.* Boston, MA: Harvard Business School Press.

Pink, D.H. (2005). *A whole new mind: Moving form the information age to the conceptual age.* New York: Riverhead Books.

Roam, D. (2008). *The back of the napkin: Solving problems and selling ideas with pictures.* New York: Penguin.

Schwartz, P. (1991). *The art of the long view: Planning for the future in an uncertain world.* New York: Currency Doubleday.

Tufte, E.R. (1990). *Envisioning information.* Los Angeles: Graphic Press.

Tufte, E.R. (2001). *The visual display of quantitative information* (2nd ed.). Los Angeles: Graphic Press.

Ulrich, D. (1997). *Human resource champions.* Boston, MA: Harvard Business School Press.

Wurman, R.S. (1989). *Information anxiety.* New York: Doubleday.

Wurman, R.S. (1997). *Information architects.* New York: Watson-Guptill Publishers.

Zakaria, F. (2006). *The post-American world.* New York: W.W. Norton.

Subscriptions

The Atlantic (magazine) at www.theatlantic.com

Good Morning Silicon Valley at http://blogs.siliconvalley.com/gmsv/

The New York Times online at http://nytimes.com

The Wall Street Journal online at http://online.wsj.com/public/us

CHAPTER

8

CHART YOUR COURSE

Now that you have spent time with the preceding chapters, what would you like to do with your new learnings? We assume that every reader has differing experiences with performance improvement and may have specific next steps in mind. To support a range of action plans, we offer suggestions at the three organizational levels: Worker/Self, Work/Process, and Workplace/Organization. Regardless of your work situation—corporate, government, non-profit, or independent—there is information you can use in this chapter.

WORKER/SELF

Let's explore possible elements of an action plan you can develop for your own continued professional development, to include:

- Results you are seeking

- Inputs you need: new skills, knowledge, abilities

- Suggested route to the inputs you have identified

- Personal development plan you will create

- Elevator story you will tell

Results

Following good performance consulting practice, what are your plans for your career? Do you want, for example, to be a performance analyst, a designer, a project manager, chief performance officer, or something else? Do you want to enhance your skills, knowledge, and abilities for the job you have

now? Give this some thought, if you haven't already, because you need to know where you are going before you get on the road.

Inputs

Now that you have identified your personal results, what are the skills, knowledge, and abilities you need to accomplish them? We are often asked this question. One answer, in its simplest form, is to consider what a hiring executive looks for when recruiting a performance improvement professional. Essentials include:

- Analytical skills/problem solving

- Presentation design and delivery

- Rapport building

- Written communication skills

- Project management

- Solution identification

- Evaluation skills

Suggested Routes to Skills, Knowledge, Abilities

There are two routes to the acquisition of the essentials listed above. One is formal and includes certifications, degree programs, seminars, workshops, and institutes offered through colleges, universities, and professional associations.

The other route is informal and requires some initiative and ingenuity on your part. Some ideas to get you started:

- Fire up your favorite Internet search engine and look up these keywords: performance improvement, performance technology, performance consulting and discover a wealth of information about practitioners, publications, and professional societies.

- Build a broad and varied professional network with an active and involved membership in a professional society through which you can access the formal learning activities mentioned earlier as well as mentors and coaches to guide you in your continued learning.

- Go back through the chapters in this book and take a look at the Authors' Picks lists at the end of each for publications we heartily recommend.

- Watch for forming project teams in your current workplace that offer opportunities for you to learn on the job—and get yourself assigned to the ones that interest you.

- Cultivate relationships with people in your organization who can enhance your knowledge, like other performance improvement professionals, and potential partners from core business groups. Pay particular attention to the finance group: these are the people who summarize business goals and results on a quarterly and yearly basis. Learnings and relationships developed here can really pay off.

Bedside Manner. Have you ever been to see a competent medical doctor who was a terrific scientist but an intimidating, cold human being? What this person lacked was bedside manner, the ability to relate to others in a congenial and supportive way while maintaining a professional demeanor and earning their trust. A valued performance improvement specialist is like your favorite doctor—both must have the processes necessary for success as well as the practices or actions that build trust and credibility.

Get Certified. There are a number of certification programs available to you to enhance your professional standing. Some are multi-course programs that take a survey approach to performance improvement, while others are more focused on specialties within the field. Some require a greater commitment of time and effort and some ask less. Look for a certification that enhances your professional goals.

One requirement that we are seeing listed in an increasing number of performance improvement position descriptions is the Certified Performance Technologist (CPT) designation. This is a proficiency-based professional credential you can earn through the International Society for Performance Improvement (ISPI). Earning the CPT is a valuable developmental investment you can make in yourself. Go to www.ispi.org for information on certification.

Personal Development Plan

The performance improvement literature is filled with examples of action plans designed to help people make their desired results concrete. Personal development plans are typically included in performance planning documents and often exist within the organizations where you work. You might like to adapt one of these forms to guide you in the next steps you are outlining for yourself.

If you need a planning form, we include one here that we have used successfully. It is based on the RSVP+ Principles that we discuss throughout this book. Feel free to modify the form in Exhibit 8.1 and make it work for you.

EXHIBIT 8.1. **RSVP+ Action Plan Guidelines**

Read the guidelines below and identify the top three results you plan to achieve. For each result, complete a separate copy of the chart below. Then transfer your actions and dates to your calendar.

1. Focus on Results
 - Identify the results you want to achieve.
 - Write them down and rank them.

2. Take a System Viewpoint
 - What do you have to do to achieve the results?
 - Identify the required actions for each result.
 - What other parts of the system may be affected by this action?

3. Add Value
 - Focus on high-value results.
 - Eliminate low-value activities (they add cost and time).
 - Identify the time required for each high-value activity.
 - Decide when you will begin each activity and schedule it on your calendar.
 - Focus on the accomplishments rather than the activities.

4. Identify Your Partners.
 - Who will you partner with?
 - What will you require from him or her?
 - When will you contact the person?
 - When will you follow up?

RSVP	Action	Date
Results		
System Viewpoint		
Value		
Partners		

©ISPI 2008. Used with permission.

Remember, you will not get anything accomplished if you do not schedule the time and **DO** it.

Elevator Speech

The concept of an elevator speech is familiar to many. It is a thirty- to sixty-second self-promotional story that tells an inquiring person what your work is and how it might benefit him or her. It can cover a specific product, service, or project. The speech is delivered in the time it takes to complete an elevator ride. An elevator speech consists of:

■ A statement about problems you can solve or services you can deliver

■ Possible solutions to typical problems or opportunities

■ What makes you unique

■ A success story

One of us shares an elevator speech here:

> *"I help managers understand their organizations better and get the improvements they need. I find reasons for things like dropping sales rates or increased employee turnover. My ability to see things with a fresh pair of eyes makes my services valuable to clients.*

> *"Recently, I worked with a big box sporting goods store. Bicycle accessory sales were below projections. Management thought the accessory sales clerks lacked sales skills. We began by looking at what customers needed to be satisfied. We found that the add-ons for bikes, like shocks, performance handlebars, or spinners were in a different department from the bike shorts, helmets, gloves, and other clothing items, so customers had to make two stops. We helped the manager build a map showing what each department needed to satisfy a bicycle accessory customer. Once the managers could see what was needed to make customers happy, they reorganized the workflow to improve customers' buying experience. Sales went up immediately."*

WORK/PROCESS

Are you currently managing a training department, organization development team, or other performance improvement-focused group? Or do you aspire to head such a group? If your answer is yes, then we have a modest proposal for you. Someone has to manage the performance improvement efforts in an organization, so why not use what you've learned from this book to construct a performance improvement department to lead the effort?

Performance Improvement Department

We've seen any number of organizations in which several different groups are focused on performance improvement, each with its special technology, working hard to make a difference. Think of human resources, learning and development, information technology, business process improvement, quality assurance, and others. Since these groups are all aiming for the same end result, why not pull them together as one skilled team in the performance improvement department? Imagine the potential value to the organization that a group of performance improvement specialists with skills in Six-Sigma., lean manufacturing, organization development, training, performance technology, human factors, and related disciplines could have.

Rather than attacking the same problems independently and from one perspective at a time, a combined team could identify the most appropriate techniques from among the many represented to improve performance in a cohesive way. Clients would be able to access the combined technologies for results:

- Human Performance Technologies—focused on people

- Process Performance Technologies—focused on process and procedure

- Organization Performance Technologies—focused on organization development

And of course, the newly established performance improvement department will require a manager.

Chief Performance Officer. A chief performance officer (CPO) could manage this new group, eliminating duplicate efforts, achieving economies of scale, and leveraging skills and influence to bring change across the enterprise. This manager would be able to integrate functions to gain support for performance improvement initiatives. Working both vertically, within functional lines, and horizontally across them, the CPO would have a unique and valuable line of sight (see Chapter 4: The Workplace: Organization Level, for more on line of sight) that could increase credibility for performance improvement and the results produced.

With the CPO's leadership, much of the confusion each of the disciplines causes clients, with unique language, models, and approaches, could be streamlined into a focus on the total performance system of the organization. Integrating all the related disciplines under a CPO has great potential for client satisfaction.

Elements of the Performance Improvement Department. Do you recall the Total Performance System (TPS) first introduced In Chapter 2, The Worker: Individual/Team Level, as a tool performance consultants can use to analyze an organization? You can also use the TPS to build an organization from the beginning or modify an existing one. While other tools are available, we suggest the TPS because it is familiar. Begin in the usual place, with the results you want to produce, and follow with the remaining RSVP principles, first introduced in Chapter 1, The Performance Technology Landscape. A quick review:

R—Focus on results: Initiate projects by specifying what the end result is to be.

S—Take a system viewpoint: Consider all aspects of the organization's performance system.

V—Add Value: Produce results that make a difference.

P—Establish Partnerships: Work with clients and other specialists to share skills, knowledge, creativity, and successes.

RSVP becomes the four-legged foundation for the performance improvement department you are building. Now you are ready to use the TPS model to structure your PI department. Look at Table 8.1. The elements are the same as those for a TPS analysis except the "receivers" are now identified as "stakeholders." The definitions have been adjusted to focus on the construction of a new department. Your task is to complete the Examples column with specifics for your organization. We filled one in to get you started.

TABLE 8.1. **Total Performance System.**

Element	Definition	Example
Stakeholders	Internal clients, external customers, organization's improved performance	Customers, employees, shareholders
Results	Repeat business, increased productivity	
Outputs	Problems solved, recommendations made, opportunities identified	
Processes	Performance analysis, project management, consulting, solution design, partnering, presentation development, implementation, change management, business case development, evaluation methodology, proposal development	
Inputs	Client requests, funding, Mission, Vision, Values, Goals, performance consultants, organizational data, client and organization expectations, exemplary performers	
Conditions/Business Environment	Internal/external environments, trends	
Performance Feedback	Process feedback to ensure alignment	
Value Feedback	Feedback from clients and organization	
Culture—Organization and Region	The way we do things around here, this is the way it is	

Source: ©2008 International Society for Performance Improvement. Used with permission.

With a TPS completed for your new PI department, you are on your way to establishing a team with tremendous potential in your organization.

WORKPLACE/ORGANIZATION

How does a newly created team or department become an effective operation within the larger organization? How will your PI department assimilate into the enterprise?

We Are Known by Our Results

We suggest that your new group make itself known by the results it delivers. Many performance improvement specialists try to educate their clients about HPT. We don't recommend this approach. Your clients are interested in what you can do for them, in the results you can achieve, not in the methods you use to get them. No one cares how the marketing department does its work; they care about the good advertising they produce. Performance improvement is no different.

The Educated Client

That said, a client with no interest in the work of your PI department would not be seeking your services for long. An ideal client is an educated client; educated about the results your team can deliver, educated about your products and services, educated about how best to partner with you and champion your work. And it is your responsibility to help your client learn.

Set Expectations

As we see it, clients have two main responsibilities when they partner with a performance improvement group:

- Create a business case for their project in cooperation with the PI department

- Make certain that the project has a senior management champion to keep results visible and ensure a successful implementation

In return, the PI group is responsible for setting expectations with the client for the results to be achieved.

CONCLUSION

To help you determine how best to put to use the information you have gleaned from this book, we have aligned possible next steps you can choose from with the three organizational levels: Worker/Self, Work/Process, and Workplace/Organization. For each, we provided a suggested route to follow to achieve your personal career goals. Along the way, we revisited the RSVP+ principles and applied them to action planning, provided a generic Personal Development Plan worksheet you can customize for your needs, and applied the TPS model as a tool for constructing a Performance Improvement department. It is useful to note that many of the models and tools for performance analysis that we have shared in this book are also suitable for constructing a performance improvement organization.

AUTHORS' PICKS

Brethower, D. (1982). The total performance system. In R.M. O'Brien, A.M. Dickinson, & M.P. Rosow (Eds.). *Industrial behavior modification: A management handbook* (pp. 350–390). New York: Pergamon Press.

Crafting a killer elevator pitch. (2008, July). *Wells Fargo small business roundup.* Available: www.wellsfargo.com/biz/education/publications/small_business

Performance International. Available: www.performanceinternational.com

Thomas, M.N. (2000, August). Out-based job descriptions: Beyond skills and competencies. *Performance Improvement. 39*(7), 23–27.

AFTERWORD

It has been said that most managers understand their businesses better than they understand their organizations. Human performance technology (HPT) provides tools that enable managers to know their organizations better and get the kind of improvements they need. With HPT, managers can become *master mechanics;* that is they can "tune up" their part of the organization to produce the best results with the resources available. But that's not all. HPT also allows managers to become *master inventors,* providing them with the ability to produce innovative change to better meet the demands of an ever-changing marketplace.

At its fundamental level, every organization is a human performance system. It was founded by people, run by people, for the sole purpose of delivering value to the people who are its stakeholders (customers, owners, employees, vendors, and so on). It is only logical that any effect of a comprehensive approach to organizational performance improvement must begin with such a premise.

Every year we see a host of new books touting some innovative solutions for business success. Unfortunately few of these "solutions" have produced any long-lasting effect. In spite of large investments they soon become "flavor of the month." In contrast, HPT, rather than fading, has continued to grow in its applications over the years. The reason is that unlike most other approaches, HPT is built on solid behavioral research and systems theory, and derives its applications from a set of principles.

The authors have provided the clearest and perhaps one of the most useful books for managers ever developed. It does not focus on any one part of the organization, but views the organization as a system. It considers factors affecting people, processes, and management and leadership power, and how these must be aligned to work together to produce results. Too often books designed for managers focus on only one area and present solutions almost as magical formulas. This is a practical book that summarizes over forty years of proven success.

Finally, a book about results, and more than that, a book about how to get results!

Donald A. Tosti
Principal,
Vanguard Consulting Inc.
San Rafael, California
October 2008

APPENDIX

Workshops and Conferences

Business Process Management Conferences
ISPI Annual and Fall Conferences
ISPI, Performance Improvement: Principles and Practices
ISPI, Professional Series
Organization Development Conferences
Six Sigma and Lean Conferences

Organizations

American Society for Quality
600 North Plankinton Avenue
Milwaukee, Wisconsin 53203
USA
 P: 1.414.298.8789
 www.asq.org/

American Society for Training and Development
1640 King Street
Alexandria, Virginia 22313-1443
USA
 P: 1.703.683.8100
 F: 1.703.683.8103
 www.astd.org/

International Society for Performance Improvement

1400 Spring Street, Suite 260

Silver Spring, Maryland

USA

> P: 1.301.587.8570
>
> F: 1.301.587.8573
>
> www.ispi.org/

OD Network

71 Valley Street

Suite 301

South Orange, New Jersey 07079

USA

> P: 1.973.763.7337
>
> F: 1.973.763.7488
>
> www.odnetwork.org/

Websites

Binder-Riha Associates

> www.binder-riha.com/

Business Process Trends

> www.businessprocesstrends.com/

The Center for Effective Performance, Inc.

> www.cepworldwide.com/index.html

Daniel H. Pink

> www.danpink.com/

Darryl Sink and Associates, Inc

> www.dsink.com/

Exemplary Performance

> www.exemplaryperformance.com/

Harold Stolovitch and Associates

> www.hsa-ltd.com/

HPT in Health Care (USAID)

> www.pihealthcare.org/news.htm

Improving Workplace Performance

> www.aboutiwp.com/

Mark Graham Brown Management Consulting

> www.markgrahambrown.com/

Michael Greer's Project Management Resources

> www.michaelgreer.com

MMHA The Managers' Mentors

> www.mentors-mmha.com/

Performance Design International

http://improving-performance.net/

Performance Design Lab

www.performancedesignlab.com/

Performance International

www.performanceinternational.com

Performance Technology Center (U.S. Coast Guard)

www.USCG.MIL/TCYORKTOWN/PTC/index.shtm

Prime II Performance Tool Kit

www.prime2.org/sst/tools.html

ROI Institute

www.roiinstitute.net/

TED Ideas Worth Spreading

www.ted.com/

The Back of the Napkin

www.thebackofthenapkin.com/

The Human Performance Company

www.aubreydaniels.com/home/default.asp

The Masie Center: Learning Lab and ThinkTank

www.masieweb.com/

Workshops by Thiagi

www.thiagi.com/

Keeping Up-To-Date

Google™ or your favorite web search engine:

Business Process Management

Ergonomics

Human Factors

Human Performance Technology

Industrial Engineering

Lean Manufacturing

Organizational Development

Performance Engineering

Performance Improvement

Six Sigma

System Engineering

Systems Theory

Articles, Books, and Presentations by

Alan Ramias

Allison Rossett

Arnoud Vermei

Aubrey Daniels

Belia Nel

Bill Daniels

Brenda Sugrue

Carl Binder

Carol Haig

Carol Panza

Cedric Coco

Christian Voelkl

Clare Carey

Dale Brethower

Danny Langdon

Darryl Sink

David Ulrich

Deborah Stone

Diane Gayeski

Donald Tosti

Doug Leigh

Elliott Masie

Fred Nickols

Geary Rummler

George Geis

Harold Stolovitch

Jack and Patti Philips

Jack Zigon

Jeanne Farrington

Jim and Dana Robinson

Jim Evans

Jim Hill

Jim Pershing

Joe Harless

Judith Hale

Ken Silber

Klaus Wittkuhn

Lloyd Homme

Lynn Kearny

Marc Rosenberg

Margo Murray

Mark Graham Brown

Mark Munley

Michiel Bloem

Miki Lane

Paul Elliott

Paul Harmon

Peter Drucker

Ray Svenson

Richard Clark

Richard Pearlstein

Rob Foshay

Robert Brinkerhoff

Robert Carleton

Robert Mager

Rodger Stotz

Roger Chevalier

Roger Kaufman

Ruth Clark

Ryan Watkins

Sivasailam (Thiagi) Thiagarajan

Steve Villachica

Will Thalheimer

William Rothwell

REFERENCES

Addison, R.M. (2004, July). Performance architecture: A performance improvement model. *Performance Improvement, 43*(6), 14–16.

Addison, R.M. (2007, April). *Performance technology: The integrator.* Available: www.hsa-lps.com/E_News/ENews_Apr07/HSA_e-Xpress_Apr07.htm.

Addison, R.M., & Haig, C. (1999). Human performance technology in action. In H. Stolovitch & E. Keeps (Eds.), *Handbook of human performance technology* (2nd ed.). San Francisco, CA: Jossey-Bass/Pfeiffer.

Addison, R.M., & Haig, C. (2006). The performance architect's essential guide to the performance technology landscape. In J.A. Pershing (Ed.), *The handbook of human performance technology* (3rd ed.), (pp. 35–54). San Francisco, CA: Pfeiffer.

Addison, R.M., & Johnson, M. (1997). The building blocks of performance. *Business Executive, 11* (68), 3–5.

Apple and the environment. (2008, July). Available: www.apple.com/environment/recycling/nationalservices/us.html.

Block, P. (2000). *Flawless consulting* (2nd ed.). San Francisco, CA: Pfeiffer.

Brethower, D. (1982). The total performance system. In R.M, O'Brien, A.M. Dickinson, & M.P. Rosow (Eds.), *Industrial behavior modification: A management handbook* (pp. 350–390). New York: Pergamon Press.

Campbell, J. (1972). *The hero with a thousand faces.* Princeton, NJ: Princeton University Press.

Carleton, J., & Lineberrry, C. (2004). *Achieving post-merger success.* San Francisco, CA: Pfeiffer.

Carr, N. (2008). Is google making us stoopid? *The Atlantic,* pp. 56–63.

China's total foreign direct investment (FDI) hits us $73.3 billion. (2007, June 6). Available: http://english.peopledaily.com.cn/200706/06/eng20070606_381475.html.

Climate change impacts stronger storms. (2008). Available: www.nature.org/initiatives/climatechange/issues/art19625.html.

Crafting a killer elevator pitch. (2008, July). *Wells Fargo small business roundup.* Available: www.wellsfargo.com/biz/education/publications/small_business.

Creating organizational transformations: McKinsey global survey results. (2008, August). Available: www.mckinseyquarterly.com/Creating_organizational_transformations_McKinsey_Global_Survey_results_2195_abstract

Drucker, P. (2001, July). *Management challenges for the 21st century.* New York: Harper Business.

Esque, T.J. (1999). *No surprises project management: A proven early warning system for staying on track.* Mill Valley, CA. ACT Publishing.

Esterbrook, G. (2007, April). *Global warming: Who loses, who wins.* Available: www.theatlantic.com/doc/200704/global-warming/2.

Friedman, T.L. (2005, 2006, 2007). *The world is flat: A brief history of the twenty-first century.* New York: Picador/Farrar, Straus and Giroux.

Friedman, T.L. (2008). *Hot, flat, and crowded.* New York: Farrar, Straus & Giroux.

Gayeski, D. (2008). *Connecting with tomorrow's workforce: Trends and technologies.* Paper presented at ISPI Annual Conference, New York City.

Gharajedaghi, J. (1999). *Systems thinking: Managing chaos and complexity: A platform for designing business architecture*: Boston: MA. Butterworth-Heinemann.

Greer, M. (1996). *The project manager's partner: A step-by-step guide to project management.* Amherst, MA. HRD Press.

Grove International. The. www.grove.com.

Haig, C., & Addison, R.M. (2002, October). TrendSpotters: Snapshots from the field featuring Edgar Necochea & Rick Sullivan. Available: www.performancexpress.org/0210/.

Haig, C., & Addison, R. (2007, August). TrendSpotters: I³ change implementation model. Available: www.performancexpress.org/0708/#2.

Haig, C., & Addison, R.M. (2007, October). TrendSpotters: RSVP+. Available: www.performancexpress.org/0710/#2.

Hale, J. (1998). *The performance consultant's fieldbook.* San Francisco, CA: Jossey-Bass/Pfeiffer.

Harmon, P. (1984). A hierarchy of performance variables. *Performance and Instruction, 23* (10), 27–28.

Heath, C., & Heath, D. (2007). *Made to stick: Why some ideas survive and others die.* New York: Random House.

Herbold, R.J. (2004). *The fiefdom syndrome.* New York: Currency Doubleday.

High oil prices hit global economies. (2008, May 28). Available: http://news.bbc.co.uk/2/hi/business/7421778.stm.

HP Invent (n.d.). *Design for environment.* Available: www.hp.com/hpinfo/globalcitizenship/environment/productdesign/design.html.

International Society for Performance Improvement. (2004, March). *ISPI Presidential Initiative Task Force final report.* Silver Spring, MD: International Society for Performance Improvement.

Kaplan, R.D. (2005, June). *How we would fight China.* Available: www.theatlantic.com/doc/200506/kaplan

Kaplan, R.S., & Norton, D.P. (1996). *The balanced scorecard* (pp. 24–29). Boston, MA: Harvard Business School Press.

Kaufman, R. (2006). *Change, choices, and consequences: Agenda to mega thinking and planning.* Amherst, MA. HRD Press.

Kearny, L., & Silber, K. (2006). Business perspectives for performance technologists. In J.A. Pershing (Ed.), *Handbook of human performance technology* (3rd ed.). San Francisco, CA: Pfeiffer.

Lane, M. (2008). Personal conversation.

Levi Strauss and Co. (2005). *Social responsibility/our commitment.* Available: www.levistrauss.com/Citizenship/CommunityInvolvement.aspx.

Lineberry, C., & Carleton, J. (1999). Analyzing corporate culture. In H. Stolovitch and E. Keeps (Eds.), *Handbook of human performance technology* (2nd ed.). San Francisco, CA: Jossey-Bass/Pfeiffer.

Lyall, S. (2008, June 27). Take out the trash precisely, now. It's the law. Available: www.nytimes.com/2008/06/27/world/europe/27garbage.html?scp=1&sq=trash+collection+England&st=nyt.

Malott, M. (2003). *Paradox of organizational change: Engineering organizational and behavioral systems analysis.* Reno, NV. Context Press.

Martin, G. (2007, January 7). *The great thirst: Looking ahead to a post-global warming life in California, 60 years hence.* Available: www.sfgate.com/cgibin/article.cgi?f=/c/a/2007/01/07/CMG9HMMTIT12.DTL&hw=California+Water&sn=002&sc=773.

McGregor, J. (2008, April 17). The world's most innovative companies. Available: http://businessweek.com/pring/magazine/contnent/08_17/b4081061866744.htm.

Merriam-Webster's Collegiate Dictionary. (2003). (11th ed.).

Moulton Reger, S. (2006). *Can two rights make a wrong? Insights from IBM's tangible culture approach.* Indianapolis: IN: IBM Press.

Performance International. Available: www.performanceinternational.com.

Pink, D. (2005). *A whole new mind: Moving from the information age to the conceptual age.* New York: Riverhead Books.

Porter, M.E. (1998). *Competitive advantage: Creating and sustaining superior performance.* New York: The Free Press.

Predict and prevent failure with five crucial conversations. (2006) Available: www.silencefails.com/solutions. html?utm_content=body.

Presidential initiative task force final report. (2004, March). Silver Spring, MD: International Society for Performance Improvement.

"Psst! Your corporate initiative is dead and you're the only one who doesn't know." (2008, February). Available: www.vitalsmarts.com/userfiles/File/pdf/Silence_Fails_Mini_WEB_020807.pdf.

Rummler, G. (2004). *Serious performance consulting: According to Rummler.* Silver Spring, MD: ISPI.

Rummler, G., & Brache, A. (1995). *Improving performance: How to manage the white space on the organization chart* (2nd ed.). San Francisco, CA: Jossey-Bass.

Schein, E. (1992). *Organizational culture and leadership* (2nd ed.). San Francisco, CA: Jossey-Bass.

Schwarz, B. (2005, June). Managing China's rise. Available: www.theatlantic.com/doc/200506/schwarz.

Serious Performance Consulting Workshop. (2005). *Performance Design Lab,* p. 112.

Siemens. (2005). *Corporate citizenship.* Available: www.hp.com/hpinfo/globalcitizenship/environment/productdesign/design.html.

Silber, K.H. (2008, June). *Calculating return-on-investment.* Available:www.silberperformance.com.

Silence fails: Study overview. (2006). Available: www.silencefails.com/about.html.

SMART goals (2008, June). Available: www.topachievement.com/smart.html.

Stolovitch, H. (2008). Beware common sense. *Talent Management,* *4*(5), 10. Available: www.nxtbook.com/nxtbooks/ mediatec/tm0508/

Stolovitch, H.D., & Maurice, J-G. (1998). Calculating the return on investment in training: A critical analysis and a case study. *Performance Improvement,* *37*(8), 9–20.

The Grove International. www.grove.com.

Thomas, M.N. (2000, August). Out-based job descriptions: Beyond skills and competencies. *Performance Improvement.* *39*(7), 23–27.

Tosti, D. (1980). *Tactics of communication.* Sausalito, CA. Operants.

Tosti, D. (2003). *Organizational alignment.* San Rafael, CA. Vanguard Consulting.

Tosti, D. (2004). Build or repair, or why I hate cause analysis (sometimes). Unpublished article, San Rafael, California.

Tosti, D. (2006, March). Process is only half the story. *Business Process Trends.*

Tosti, D. (2007, April). What makes human performance technology different. PerformanceXpress. Available: http:// performancexpress.org/0704

Tosti, D., & Jackson, S. (1994, April). Organizational alignment: How it works and why it matters. *Training* pp. 58–64.

U.S. Green Building Council. Available: www.usgbc.org/DisplayPage.aspx?CMSPageID=222

Uttal, B. (1983, October 17). The corporate culture vultures. *Fortune,* p. 29.

Wittkuhn, K.D. (2004). Models, systemic thinking, and unpredictability in consulting. *Performance Improvement,* *43*(6), 17–19.

Wittkuhn, K. (2008, April). *Why HPT doesn't make you happy.* Paper presented at the Annual Conference of the International Society for Performance Improvement, New York City.

Zakaria, F. (2008). *India: Asia's other superpower breaks out.* Available:www.msnbc.msn.com/id/11571348/site/ newsweek/

FURTHER READINGS

Addison, R.M., & Haig, C. (1999). Performance technology in action. In H.D. Stolovitch & E.J. Keeps (Eds.), *The handbook of human performance technology* (2nd ed.). San Francisco, CA: Jossey-Bass/Pfeiffer.

Addison, R.M., & Wittkuhn, K.D. (2001). HPT: The culture factor. *Performance Improvement, 40*(3), 14–19.

Brache, A.P. (2002). *How organizations work: Taking a holistic approach to enterprise health.* Hoboken, NJ: John Wiley & Sons.

Brethower, D. (2007). *Performance analysis: Knowing what to do and how.* Amherst, MA: HRD Press.

Bundles of templates for business process improvement. (2008, July). Systems2win. Available: http://systems2win. com/

Carlton, R.J., & Lineberry, C.S. (2004). *Achieving post-merger success.* San Francisco, CA: Pfeiffer.

Charan, R., & Bossidy, L. (2002). *Execution: The discipline of getting things done.* New York: Crown Business Books.

Conner, D.R. (1994). *Managing at the speed of change: How resilient managers succeed and prosper where others fail.* New York: Villard.

Easy flowchart software. (2008, July). SmartDraw. Available: www.smartdraw.com/specials/flowchart.asp

Flow charts: Understanding and communicating how a process works. (2008, July). Available: www.mindtools.com/pages/article/newTMC_97.htmMind

Friedman, T.L. (2009). *Hot, flat and crowded: Why we need a green revolution—and how it can renew America.* New York: Farrar, Straus & Giroux.

Gilbert, T.F. (1996). *Human competence: Engineering worthy performance.* Silver Spring, MD, and Amherst, MA: ISPI and HRD Press.

Guerrera-Lopez, I.J. (2008). *Performance evaluation: Proven approaches for improving program and organizational performance.* San Francisco, CA: Jossey-Bass.

Hale, J. (1998). *The performance consultant's fieldbook: Tools and techniques for improving organizations and people.* San Francisco, CA: Jossey-Bass/Pfeiffer.

Hale, J. (2002). *Performance-based evaluation: Tools and techniques to measure impact of training.* San Francisco, CA: Pfeiffer.

Harmon, P. (2002). *Business process change.* San Francisco, CA: Morgan Kaufman.

Heath, C., & Heath, D. (2007). *Made to stick.* New York: Random House.

Kaplan, R.S., & Norton, D.P. (2004). *Strategy maps.* Cambridge, MA: Harvard Business School Press.

Kaufman, R. (2006). *Change, choices, and consequences: A guide to mega thinking and planning.* Amherst, MA: HRD Press.

Kearny, L., & Silber, K.H. (2000, April). *Wearing business glasses: Tying HPT and HR to bottom-line metrics.* Paper presented at the Annual Conference of the International Society for Performance Improvement, New York City.

Kotter, J.P. (1992). *Corporate culture and performance.* New York: The Free Press.

Kriegel, R., & Brandt, D. (1997). *Sacred cows make the best burgers: Developing change-ready people and organizations.* New York: Warner Books.

Kriegel, R., & Patler, L. (1991). *If it ain't broke . . . break it: And other unconventional wisdom for a changing business world.* New York: Warner Books.

Microsoft Office online. (2008, July). Available: http://office.microsoft.com/en-us/word/HA010552661033.aspx/

OmniGraffle: Diagramming worth 1000 words. (2008, July). Available: www.omnigroup.com/applications/OmniGraffle

Porter, M.E. (1998). *Competitive strategy: Techniques for analyzing industries and competitors.* New York: The Free Press.

Professional flowcharting. (2008, July). Available: RFFlow www.rff.com/

Reger, S.J.M. (2006). *Can two rights make a wrong: Insights from IBM's tangible culture approach.* Upper Saddle River, NJ: IBM Press.

Rummler, G.A., & Brace, A.P. (1995). *Improving performance: How to manage the white space on the organization chart* (2nd ed.). San Francisco, CA: Jossey-Bass.

Senge, P.M., Kleiner, A., Roberts, C., Ross, R., & Smith, B. (1994). *The fifth discipline fieldbook: Strategies and tools for building a learning organization.* New York: Doubleday.

Stolovitch, H.D., & Keeps, E.J. (2004). *Training ain't performance.* Alexandria, VA: ASTD.

Trompenaars, F., & Turner, H. (1997). *Riding the waves of culture: Understanding cultural diversity in business.* Yarmouth, ME: Brealey.

Van Tiem, D., Moseley, J.L., & Dessinger, J.C. (2001). *Performance improvement interventions: Enhancing people, processes, and organizations through performance technology.* Silver Spring, MD: International Society for Performance Improvement.

Wittkuhn, K.D. (2004). Models, systemic thinking, and unpredictability in consulting. *Performance Improvement, 43*(6), 17–19.

Zakaria, F. (2006). *The post-American world.* New York: W.W. Norton.

Zemke, R., & Kramlinger, T. (1982). *Figuring things out: A trainer's guide to needs and task analysis.* Reading MA: Addison-Wesley.

INDEX

Page references followed by *fig* indicate an illustrated figure; followed by *t* indicate a table; followed by *e* indicate an exhibit.

ABOUT THE AUTHORS

Roger M. Addison, CPT, is an internationally respected practitioner of human performance technology (HPT) and performance consulting. He is the senior director of human performance technology for the International Society for Performance Improvement (ISPI). Roger was a vice president and manager at Wells Fargo. He consults with Fortune 500 organizations to help them align their business requirements with bottom-line results. Roger has worked and presented in North America, South America, Asia, Europe, Africa, and the Middle East and successfully implemented performance improvement initiatives in many organizations.

Roger is a frequent speaker at the International Society for Performance Improvement (ISPI), the International Federation of Training and Development Organisations (IFTDO), and the American Society for Training and Development (ASTD). Topics include Performance Technology, Performance Architecture, Reengineering, Information Design, Mentoring, Consulting, Project Management and Communication Networks.

Roger is a past president and past chair of the board of IFTDO and past president of ISPI. Roger received ISPI's awards for Member of the Year, Organization of the Year, and Outstanding Product. In 1998 he received ISPI's highest award, Member for Life. Roger received his master's and doctoral degrees in educational psychology from Baylor University. He can be reached at rogeraddison@ earthlink.net

Carol Haig, CPT, is principal of Carol Haig & Associates, a performance improvement consulting firm founded in 1998. She has over thirty years of experience helping line and staff managers improve the performance of their employees in information technology, insurance, financial services, public utilities, communication, healthcare, and other industries. Carol specializes in performance analysis, needs assessment, and new-hire orientation.

Carol is on the faculty of the Performance Improvement: Principles and Practices Institute offered by ISPI. She is a past director of ISPI's executive board and writes regularly for the online publication, PerformanceXpress. She is the recipient of several coveted ISPI awards for her professional contributions and presents regularly at professional conferences.

Carol also applies her performance improvement skills and knowledge to help callers on a community crisis hotline. She believes that anyone with management responsibility requires basic needs analysis skills to handle the many challenges each workday presents.

Contact Carol at carolhaig@earthlink.net. Visit her webpage at http://home.mindspring .com/~carolhaig

Lynn Kearny, CPT, leads a performance consulting firm in Oakland, California. She has wide experience assessing organizational needs and designing and developing performance improvement solutions. She also plans and graphically facilitates client meetings and think tanks. Her graphics communicate complex and abstract ideas in a clear, memorable way.

Lynn has a broad and effective toolbox of facilitation techniques for training and organizational meetings. She excels in involving participants and giving them both the means and the self-confidence to immediately apply learning through discovery and practice. Lynn mixes graphics, language, stories, and hands-on exercises, drawing on solid scientific evidence of learning psychology.

She has worked in America, Europe, Asia, and Africa. Clients include financial, manufacturing, retail, high-tech, governmental, and non-profit organizations. Lynn served on ISPI's international board of directors and is currently faculty for both of ISPI's HPT Institutes. She has contributed chapters and articles and published three books relating to performance improvement. You can reach her at lkearny@sprintmail.com, web page at www.ifvp.org/directory/lkearny/index.htm.

Pfeiffer Publications Guide

This guide is designed to familiarize you with the various types of Pfeiffer publications. The formats section describes the various types of products that we publish; the methodologies section describes the many different ways that content might be provided within a product. We also provide a list of the topic areas in which we publish.

FORMATS

In addition to its extensive book-publishing program, Pfeiffer offers content in an array of formats, from fieldbooks for the practitioner to complete, ready-to-use training packages that support group learning.

FIELDBOOK Designed to provide information and guidance to practitioners in the midst of action. Most fieldbooks are companions to another, sometimes earlier, work, from which its ideas are derived; the fieldbook makes practical what was theoretical in the original text. Fieldbooks can certainly be read from cover to cover. More likely, though, you'll find yourself bouncing around following a particular theme, or dipping in as the mood, and the situation, dictate.

HANDBOOK A contributed volume of work on a single topic, comprising an eclectic mix of ideas, case studies, and best practices sourced by practitioners and experts in the field.

An editor or team of editors usually is appointed to seek out contributors and to evaluate content for relevance to the topic. Think of a handbook not as a ready-to-eat meal, but as a cookbook of ingredients that enables you to create the most fitting experience for the occasion.

RESOURCE Materials designed to support group learning. They come in many forms: a complete, ready-to-use exercise (such as a game); a comprehensive resource on one topic (such as conflict management) containing a variety of methods and approaches; or a collection of like-minded activities (such as icebreakers) on multiple subjects and situations.

TRAINING PACKAGE An entire, ready-to-use learning program that focuses on a particular topic or skill. All packages comprise a guide for the facilitator/trainer and a workbook for the participants. Some packages are supported with additional media—such as video—or learning aids, instruments, or other devices to help participants understand concepts or practice and develop skills.

- *Facilitator/trainer's guide* Contains an introduction to the program, advice on how to organize and facilitate the learning event, and step-by-step instructor notes. The guide also contains copies of presentation materials—handouts, presentations, and overhead designs, for example—used in the program.

- *Participant's workbook* Contains exercises and reading materials that support the learning goal and serves as a valuable reference and support guide for participants in the weeks and months that follow the learning event. Typically, each participant will require his or her own workbook.

ELECTRONIC CD-ROMs and web-based products transform static Pfeiffer content into dynamic, interactive experiences. Designed to take advantage of the searchability, automation, and ease-of-use that technology provides, our e-products bring convenience and immediate accessibility to your workspace.

METHODOLOGIES

CASE STUDY A presentation, in narrative form, of an actual event that has occurred inside an organization. Case studies are not prescriptive, nor are they used to prove a point; they are designed to develop critical analysis and decision-making skills. A case study has a specific time frame, specifies a sequence of events, is narrative in structure, and contains a plot structure—an issue (what should be/have been done?). Use case studies when the goal is to enable participants to apply previously learned theories to the circumstances in the case, decide what is pertinent, identify the real issues, decide what should have been done, and develop a plan of action.

ENERGIZER A short activity that develops readiness for the next session or learning event. Energizers are most commonly used after a break or lunch to stimulate or refocus the group. Many involve some form of physical activity, so they are a useful way to counter post-lunch lethargy. Other uses include transitioning from one topic to another, where "mental" distancing is important.

EXPERIENTIAL LEARNING ACTIVITY (ELA) A facilitator-led intervention that moves participants through the learning cycle from experience to application (also known as a Structured Experience). ELAs are carefully thought-out designs in which there is a definite learning purpose and intended outcome. Each step—everything that participants do during the activity—facilitates the accomplishment of the stated goal. Each ELA includes complete instructions for facilitating the intervention and a clear statement of goals, suggested group size and timing, materials required, an explanation of the process, and, where appropriate, possible variations to the activity. (For more detail on Experiential Learning Activities, see the Introduction to the *Reference Guide to Handbooks and Annuals*, 1999 edition, Pfeiffer, San Francisco.)

GAME A group activity that has the purpose of fostering team spirit and togetherness in addition to the achievement of a pre-stated goal. Usually contrived—undertaking a desert expedition, for example—this type of learning method offers an engaging means for participants to demonstrate and practice business and interpersonal skills. Games are effective for team building and personal development mainly because the goal is subordinate to the process—the means through which participants reach decisions, collaborate, communicate, and generate trust and understanding. Games often engage teams in "friendly" competition.

ICEBREAKER A (usually) short activity designed to help participants overcome initial anxiety in a training session and/or to acquaint the participants with one another. An icebreaker can be a fun activity

or can be tied to specific topics or training goals. While a useful tool in itself, the icebreaker comes into its own in situations where tension or resistance exists within a group.

INSTRUMENT A device used to assess, appraise, evaluate, describe, classify, and summarize various aspects of human behavior. The term used to describe an instrument depends primarily on its format and purpose. These terms include survey, questionnaire, inventory, diagnostic, survey, and poll. Some uses of instruments include providing instrumental feedback to group members, studying here-and-now processes or functioning within a group, manipulating group composition, and evaluating outcomes of training and other interventions.

Instruments are popular in the training and HR field because, in general, more growth can occur if an individual is provided with a method for focusing specifically on his or her own behavior. Instruments also are used to obtain information that will serve as a basis for change and to assist in workforce planning efforts.

Paper-and-pencil tests still dominate the instrument landscape with a typical package comprising a facilitator's guide, which offers advice on administering the instrument and interpreting the collected data, and an initial set of instruments. Additional instruments are available separately. Pfeiffer, though, is investing heavily in e-instruments. Electronic instrumentation provides effortless distribution and, for larger groups particularly, offers advantages over paper-and-pencil tests in the time it takes to analyze data and provide feedback.

LECTURETTE A short talk that provides an explanation of a principle, model, or process that is pertinent to the participants' current learning needs. A lecturette is intended to establish a common language bond between the trainer and the participants by providing a mutual frame of reference. Use a lecturette as an introduction to a group activity or event, as an interjection during an event, or as a handout.

MODEL A graphic depiction of a system or process and the relationship among its elements. Models provide a frame of reference and something more tangible, and more easily remembered, than a verbal explanation. They also give participants something to "go on," enabling them to track their own progress as they experience the dynamics, processes, and relationships being depicted in the model.

ROLE PLAY A technique in which people assume a role in a situation/scenario: a customer service rep in an angry-customer exchange, for example. The way in which the role is approached is then discussed and feedback is offered. The role play is often repeated using a different approach and/or incorporating changes made based on feedback received. In other words, role playing is a spontaneous interaction involving realistic behavior under artificial (and safe) conditions.

SIMULATION A methodology for understanding the interrelationships among components of a system or process. Simulations differ from games in that they test or use a model that depicts or mirrors some aspect of reality in form, if not necessarily in content. Learning occurs by studying the effects of change on one or more factors of the model. Simulations are commonly used to test hypotheses about what happens in a system—often referred to as "what if?" analysis—or to examine best-case/worst-case scenarios.

THEORY A presentation of an idea from a conjectural perspective. Theories are useful because they encourage us to examine behavior and phenomena through a different lens.

TOPICS

The twin goals of providing effective and practical solutions for workforce training and organization development and meeting the educational needs of training and human resource professionals shape Pfeiffer's publishing program. Core topics include the following:

Leadership & Management

Communication & Presentation

Coaching & Mentoring

Training & Development

E-Learning

Teams & Collaboration

OD & Strategic Planning

Human Resources

Consulting

What will you find on pfeiffer.com?

• The best in workplace performance solutions for training and HR professionals

• Downloadable training tools, exercises, and content

• Web-exclusive offers

• Training tips, articles, and news

• Seamless on-line ordering

• Author guidelines, information on becoming a Pfeiffer Partner, and much more

Discover more at www.pfeiffer.com